WE ARE ARTISTS

For Nelly

WE ARE ARTISTS

Women who made their mark on the world

Stories and illustrations by

Kari Herbert

27 color artwork reproductions

Thames & Hudson

Contents

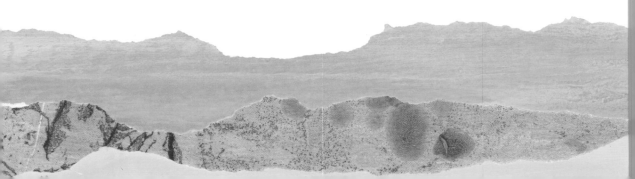

WE ARE ARTISTS

MANIFESTO

So, you want to be an awesome artist?

Pick up a brush or a pen,
It doesn't matter what...

Believe in yourself.
Let your imagination run free.

Be brave.
Stand tall.
Make your mark...

And remember
You are amazing.
You can create anything.
In art, there are no rules...

Introduction

Artists are incredibly inventive. They create from anything and everything: paint and charcoal, wire, paper, broken glass, newspapers, photographs, yarn, fabric and even macaroni. Their subjects vary wildly, too: from simple spots and vegetables to fashion and unusual landscapes; from dizzying geometric shapes to tender, soulful portraits.

This is a book about awe-inspiring artists, who also happen to be women. Women have been making marks, creating pictures and sculptures for thousands of years. They have created in every corner of the globe: in the Arctic, the desert, in jungles, on mountainsides and in valleys. One or two have even made art underwater. Some have pioneered new kinds of art, or used paint or materials in a different way. Some used art to challenge the world around them. But no matter how influential their art, how audacious their experiments, how impressive their skills or how brilliant their genius, they have not always been celebrated or recognized in the way they deserve.

Many of the women in this book overcame obstacles to become extraordinary artists and to be taken seriously in their profession. Almost all encountered prejudice. Some battled illness or anxiety. Some even had to hide their paintings in order to not be put in prison. But they all kept creating, no matter what.

For some, art is their language, their way of expressing thoughts, ideas and feelings that would be impossible to describe in words: all the stuff that goes on inside each wonderfully individual human being. Then there is the thrill in creating something that can touch the hearts and minds of millions of people. Art is immensely powerful.

There was only space to include fifteen artists in this book. I wish I could have included more. There is a whole world of other talented, awe-inspiring women artists to discover. Enough to fill many books! But what about you? In this book you will find a few ideas to get you started—perhaps you could be the next great artist of your generation. If you want to make art, do it. What you create might not seem perfect at first. But everything you make is part of your own incredible journey. Even the greatest artists had to start somewhere. And remember, gender does not define how creative you are. When it comes to creativity, there is no right or wrong way, there is simply your way.

Kari Herbert

Kenojuak Ashevak

"I am an owl, and I am a happy owl.
I am the light of happiness,
and I am a dancing, happy owl."

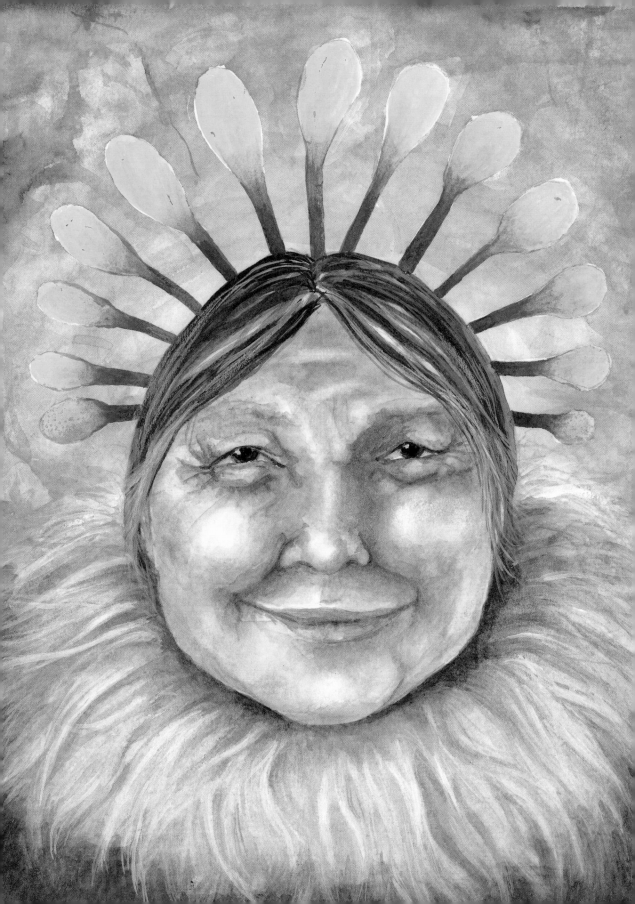

Kenojuak Ashevak
The Happy Owl

Outside the qamak the wind roared. It tugged and pulled at the sealskin tent and found its way inside, making the oily flame of the blubber lamp wobble and squirm. A strand of hair brushed her cheek. But her eyes stayed fixed as the pencil moved in her hands. It was an unfamiliar sound, that dull scratch of lead marking paper. It was the first time that she had held a pencil, or seen paper from the outside world. "It's as thin as a shell from a snow bird's egg," she thought.

A shape was appearing. The drawing was mysterious and beautiful; familiar yet otherworldly. Kenojuak slipped the drawing inside her amouti and stepped outside. Snow crunched under her sealskin boots. Cold seeped in through her clothing, but the long, dark winter was almost over and the horizon was ablaze with possibility and life. Soon the sun would rise and bring light to her world once again.

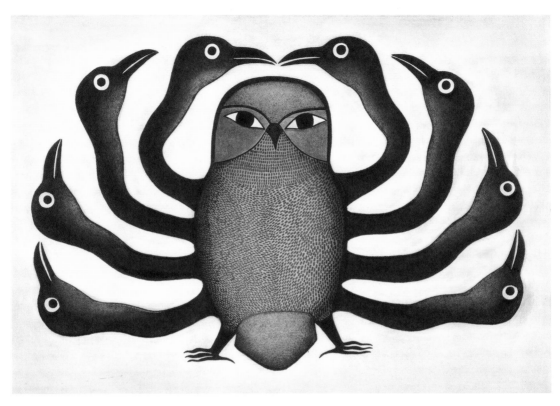

Guardian Owl, 1997

Kenojuak Ashevak was born in an igloo in a camp called Ikirasaq, on South Baffin Island, Canada. Her father was a hunter and fur trader, who was killed when she was very young. Her mother and grandmother taught her how to survive, collecting berries and eider eggs in the summer, and fishing through the ice in winter. Together they traveled from camp to camp, just as their ancestors did. They made and sold appliquéd sealskin bags and crafts to buy food. Then Kenojuak met her first husband, Johnniebo, and they started a family.

But soon Kenojuak became ill with tuberculosis, and the doctors took her away from her babies to a hospital in the city of Quebec.

For three years she was separated from the ones she loved. While she was away, two of her children died from eating rotten walrus meat. "I think my heart broke a little," Kenojuak remembered, "because when I heard, I nearly died too. I didn't care if I lived." But she eventually got better, and was allowed to go home.

In 1966, Kenojuak and Johnniebo moved to a modern village called Kinngait, so that their other children could go to school. The white people called it Cape Dorset and had built themselves wooden houses. But most of the Inuit people still lived in their animal skin tents. Here people carved pictures into bone, called scrimshaw, and made decorative crafts; but there were no paintings and no drawings. Then James and Alma Houston arrived. And everything changed.

The Houstons had seen the traditional crafts that women like Kenojuak were making, and wondered if the designs could be made into modern art. Kenojuak hadn't understood what James and Alma meant at first, as there was no one word for art in her language. So Alma had given Kenojuak pencils and some paper. James had asked her if she could draw something. When she finally showed them her picture she told them it was of a rabbit eating seaweed.

The Houstons were fascinated by what Kenojuak had created, and so were many others. It wasn't long before her drawings were being made into prints. In the beginning Kenojuak had let a hunter cut the stones for her prints. He had strong wrists from throwing the harpoon. He was happy to cut stones for Kenojuak, but she knew he would rather be hunting. Life was becoming easier, but Kenojuak, her family and her friends never forgot how when the hunt failed, their people suffered.

The prints sold all over the world from Paris to Tokyo, places that Kenojuak had never heard of. She experimented with every art material she could find—poster paints, felt-tip pens, watercolors, ink and wax crayons. She particularly loved how wax crayons filled her skin tent with their smell! She encouraged others to draw too, and helped set up a cooperative art studio, owned and run by Inuit artists. Today, it is the most productive Inuit art center in the world.

Hardworking and independent, Kenojuak became known as a pioneer of modern Inuit art. She received many honors. Some called her the "Grandmother of Inuit art." In later years, she traveled the globe to see her work exhibited, but the Arctic, her community, family and creating art were more important to her than fame.

Six-Part Harmony, 2011

Some pictures are not easy to explain. Life itself is not always easily understood. Of Kenojuak's eleven children, only five lived. But she had many grandchildren. "My gift," she once said, "is that my drawings can help provide for them. It is not just art; it is something for my life and that of my family."

As an old woman, Kenojuak would still dream of the moment that she first started drawing. She no longer lived in a skin tent, but spent her last years in her warm little home. With a pencil or felt-tip, Kenojuak would lie on a mattress on the floor and draw whatever came into her mind. She drew the land, the spirits of the birds and the animals; they called to her soul and guided her hand. She was connected to them all. After all, as she said, her spirit was a dancing, happy owl.

Barbara Hepworth

"I, the sculptor, am the landscape.
I am the form and I am the hollow,
the thrust and the contour."

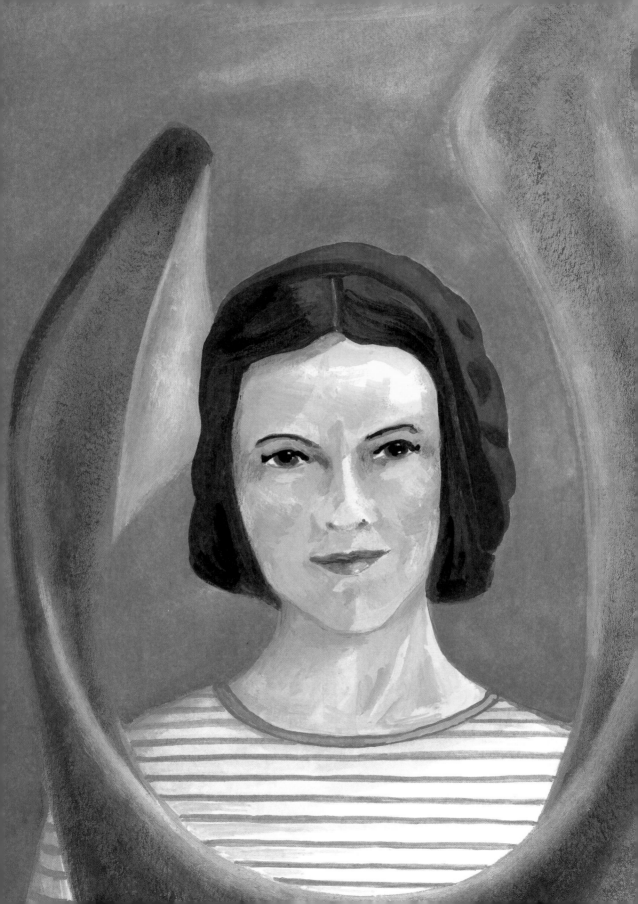

Barbara Hepworth

A Beautiful Thought

A raw, angular block of marble towered over her. The soft early morning light moved over its surface. As she gazed up at it, this huge piece of stone seemed to come alive. High on her scaffolding, Barbara circled it slowly and moved the palm of her hand over it. She picked up a large chisel with a short, flat blade, felt the weight in her hand, then picked up the hammer. The hammer came down and metal and stone sang with each strike.

Her journey with the marble had only just started and it would take her many months to complete her sculpture. She chiseled with precision, sanded the rough surface with unfaltering strength, then smoothed and polished until the raw stone had been turned into something delicate. Many people told her that she was not strong enough to become a sculptor; that women could not carve stone. She proved them all wrong.

All Barbara's early memories were of forms, shapes and textures. She grew up in Wakefield in the north of England, the center of a coal-mining district. Her father was a county surveyor and had to drive all over Yorkshire.

She went with him as often as she was allowed. Looking out of the car window, she would watch the landscape unfurl around her. She observed how the undulating hills and valleys seemed to move and flow into one another. How the roads seemed to be carefully drawn around them. There was harmony in it. She imagined holding the landscape in her hand and wondered what it would feel like.

When she went to Leeds School of Art in 1920 she wanted to recreate that experience by carving directly into stone. The other students preferred the traditional approach of modeling in clay and paying stone masons to make their sculptures for them. Barbara wanted to do things differently. She loved the rhythmical action of carving; it became like her heartbeat, her pulse. Besides, "those of us born in Yorkshire," she would say proudly, "are not afraid of hard work."

Only one other student understood her fascination with direct carving—her friend Henry Moore. They both wanted to learn the secrets of stone, how to release the magic within. Barbara and Henry began developing a form of sculpture that had never been seen before.

21

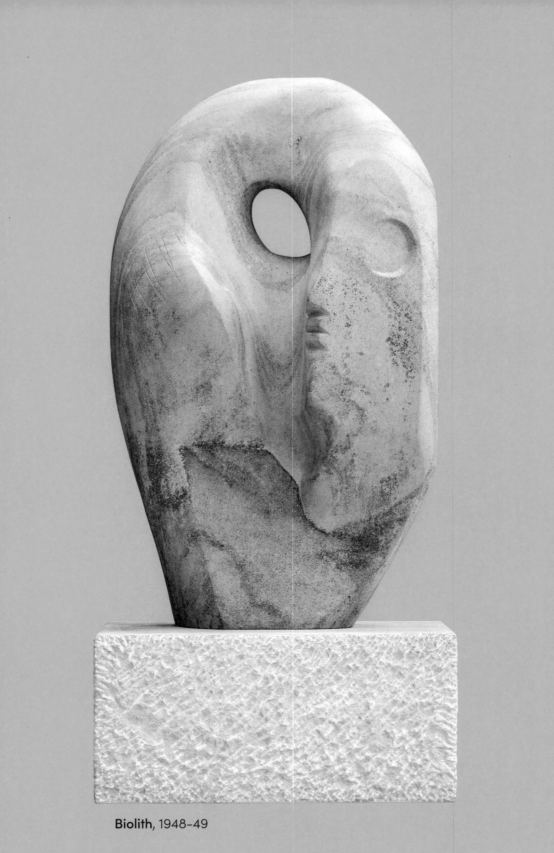

Biolith, 1948–49

They sculpted smooth, fluid-looking figures that seemed to belong in the Yorkshire landscape. After university Barbara was determined to discover more. She moved to Italy and learned to carve marble from the master-carver Giovanni Ardini. She found inspiration in the great Italian sculptors of the Renaissance and soon began creating huge sculptures far taller than herself.

Just as the Second World War began in 1939, Barbara came to the pretty seaside town of St. Ives in Cornwall with her second husband, painter Ben Nicholson. They invited pioneering artists such as the Russian sculptor Naum Gabo to join them. With other modern artists like the potter Bernard Leach and abstract artist Wilhelmina Barns-Graham nearby, St. Ives was fast becoming a hub of creativity. As artists, it was a great adventure and as exciting as making a breakthrough in science or philosophy. They were stepping out into a whole new world of expression. Together, they discovered the thrill of creating pure abstract art.

From her garden she could see the small, pretty harbor of St. Ives and, beyond, the open ocean. Around the headland, towards the west, the coastline became wild and craggy. Farther inland, the moor rose up, bearing up granite outcrops and prehistoric standing stones. Barbara was inspired to capture how the human body and nature related to one another. Her abstract forms echoed the shapes of hills, the flow of water, the swelling of clouds or the rhythms of the sea. They called all these things to mind, yet never completely described them.

The first time she made a hole through one of her sculptures was in 1932. All at once she could see the landscape behind it. The sculpture had opened up and revealed the world around it in an entirely new way. The landscape became part of the art, and the art became part of the landscape. It was as though she had discovered a new language.

Barbara became more and more preoccupied with the relationship between the inside and outside of forms. She wanted to make sculptures that stood on hillsides and that invited you to look through them and out to sea. Forms to lie down in, or climb through. She carved wood as well as stone and added fine criss-crossing strings. They looked almost like exquisite musical instruments, longing to be played.

Her fame rose in the 1950s and Barbara established herself as one of the most important sculptors in modern art. In 1965, she was made a Dame of Great Britain and many of her artworks were exhibited worldwide. Some were small enough to fit in your hand; others as tall as a double-decker bus, yet there was an intimacy in all of them. "When I am in the landscape I feel enfolded, safe, embraced," she said. "I want people to feel the same way when they see and touch my sculptures."

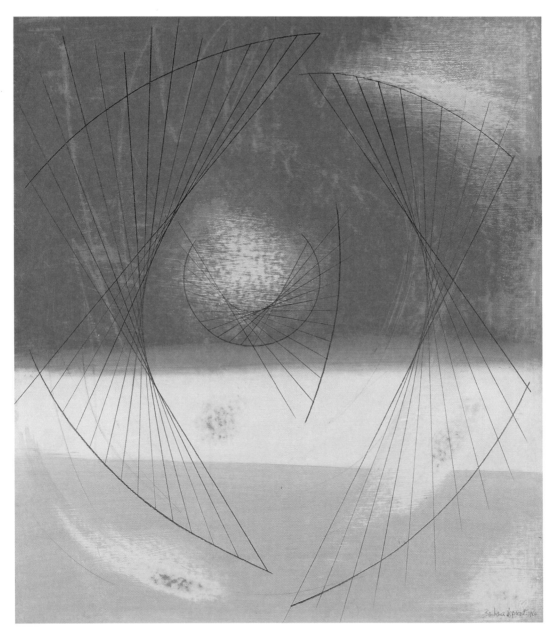

Night Sky (Porthmeor), 1964

Hannah Höch

"I have always tried to exploit the photograph. I use it like colour, or as the poet uses the word."

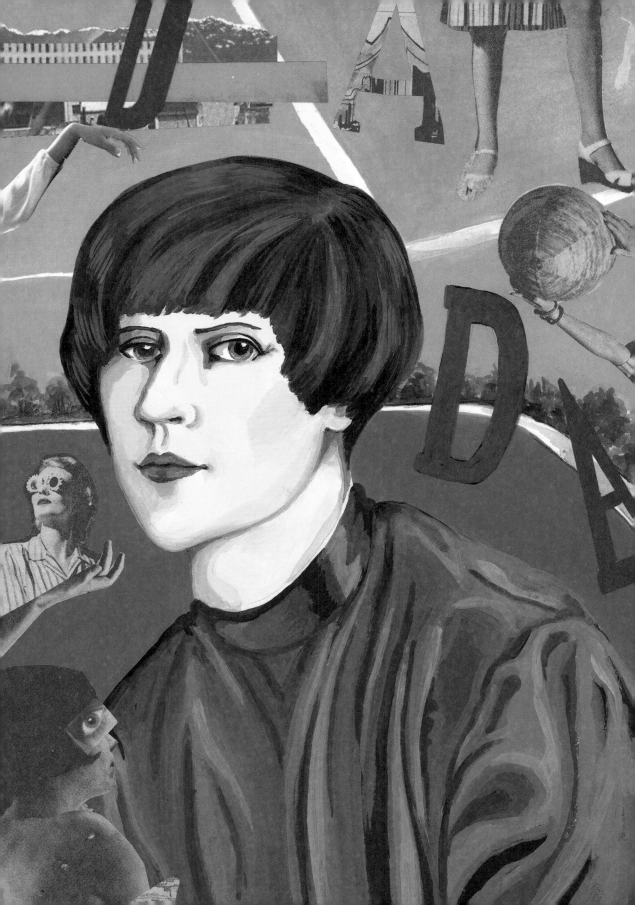

Hannah Höch
At the Cutting Edge

The apple trees were in blossom. She opened the window and breathed in the scent. Branches pushed up against the walls of her cottage. In autumn they were so heavy with fruit that they bowed to the ground. The trees had become her guardians, her protection. She enjoyed the way visitors had to duck and scramble through the tightly-knit branches to reach her front door. Besides, tucked away here she could create any kind of art she wanted, without fear.

In the beginning she had hidden because it wasn't safe. Her art was different, radical. It made some people feel uncomfortable. It enraged others. As Hitler's National Socialist party became more powerful in Germany, it became dangerous for artists like Hannah Höch to express themselves. She could have been arrested, or worse. Most of her artistic friends fled the country. She decided to stay. She bought this little cottage on the outskirts of Berlin and there she put her pictures away, and hoped that her neighbors would not discover her identity and give her away. Today Hannah's innovative legacy still lives on.

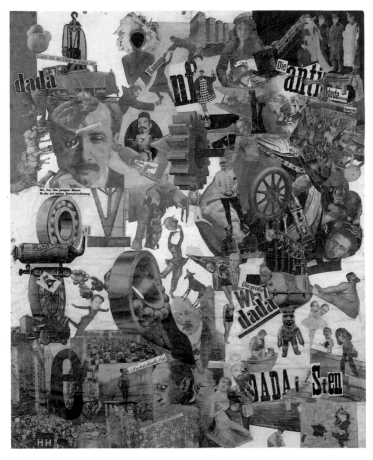

Cut with the Dada Kitchen Knife, 1919

Before the Second World War, Hannah Höch had been the first and only woman member of a group of wild and experimental artists called the Dadaists. Dada was created as a protest movement in art, poetry and theater. The art made by Hannah and her friends was not intended to be hung on the wall as grand decorations; it was created to provoke. The Dada group wanted people to talk about their art, to be shocked and enraged and for people to change their mind about what was normal. Dada was everything that was anti: anti-war, anti-politics and even anti-art.

The work produced by the Dadaists was chaotic and illogical, unusual and confusing. They celebrated nonsense and made art with materials everyone had access to. Some members created short films with people dressed in bizarre costumes that were impossible to understand, others wrote poetry by putting random words together. Hannah had her own ideas and believed that art should say something. Art could be powerful and meaningful, clever as well as humorous. And art could show how women could have a life outside of the kitchen: as artists, as working women, as anything.

Hannah had been introduced to the Dada group by her friend, the artist Raoul Hausmann. In 1918, while they were on holiday together, she saw some images that German soldiers had sent to their families, with pictures of their faces pasted onto the bodies of musketeers. She quickly realized how images could be given different meanings when they were cut and arranged together in a new way. As a woman, she had not been allowed to study fine art. Instead, she studied glass design and earned a living by working for a women's magazine writing articles and designing patterns for fashion and embroidery. Designing patterns was just like making a collage—taking the idea of a design and cutting it into different shapes before piecing them together again.

She began cutting and combining photographs found in magazines and newspapers to create surreal, intriguing art that became known as "photomontage."

Hannah Höch used photomontage to question what was normal, and to make fun of politicians and world leaders to show how ridiculous war was. To challenge how women were viewed in society. To critique what was happening around her and to ask serious questions like "what is a woman's place in the modern world" and "what is beauty?"

Hannah was as innovative as the other Dadaists but, being the only woman, she wasn't immediately accepted. Other Dada members tried to prevent her from taking part in their first exhibition. It was only because Raoul threatened to withdraw his own work from the show that Hannah was allowed to take part. The Dada movement was exciting to be part of, but was filled with big, male personalities and egos. No matter how brilliant or revolutionary her work or ideas were, to many of her colleagues Hannah was seen as just a gifted amateur, only appreciated for the sandwiches, beer and coffee she supplied, despite being as poor as all the others.

Hannah's art was to become far more influential than any of the Dadaists gave her credit for at the time. After Dada disbanded in 1922, Hannah continued her radical experiments with photomontage. Her quiet work from behind the apple trees at her cottage went on public display as soon as it was safe to show it. She never tried to become an artist for the fame. She wanted to change the way people thought. And that is exactly what she did. She may not have been appreciated during her lifetime, but Hannah helped pave the way for new ideas and inspired future generations of artists.

Tove Jansson

"If you're not afraid, how can you be really brave?"

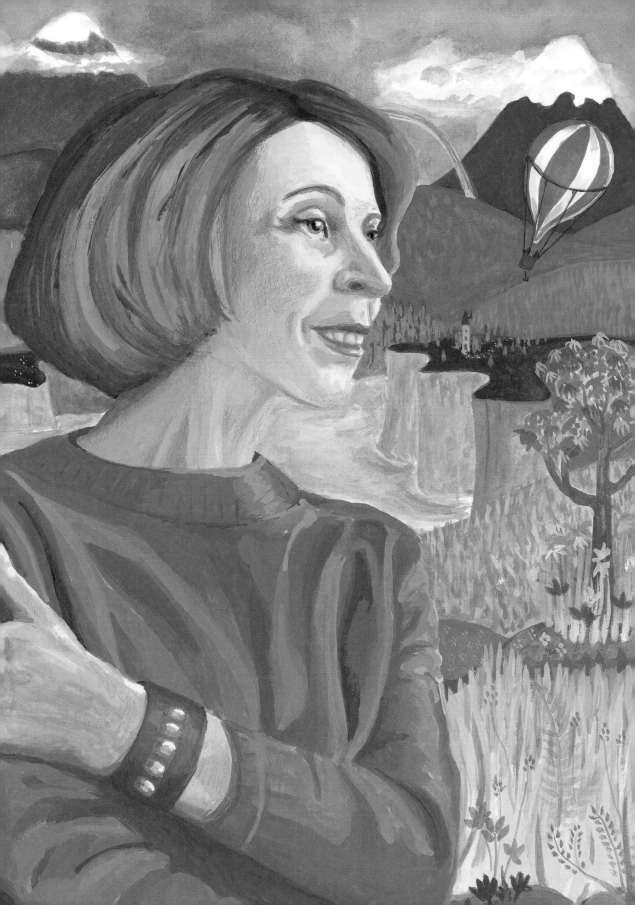

Tove Jansson

Living Art

The sea was as black as a witch's cauldron. Thunder boomed like cannons. Their small boat had been dragged up the beach and was weighed down with rocks. It was almost lost to the storm. The tent billowed and snapped. They could barely hear each other talk over the deafening sound. They chinked their mugs together and laughed. It had been like that for five days. And later Tove would remember it as being one of the happiest times of her life.

It was no wonder that Tove was so adventurous and imaginative, given how unconventional and creative her family was. Her father, Viktor, was a storm-loving sculptor, and her mother, Signe Hammarsten-Jansson, was a well-known graphic artist who rode horses and shot rifles. Everyone called her "Ham." Both Viktor and Ham encouraged Tove to do what she loved, and not be afraid to be whoever she wanted to be.

For most of the year the family lived in a ramshackle studio in Helsinki, Finland, which was filled with artworks they had made. It smelled of wet plaster and damp modelling clay, fragrant

flowers and home cooking. Everyone in the Jansson household painted, sculpted, played music or told stories, and their parties could go on for days. Visits there were unforgettable. You'd find yourself in the company of some unusual characters, like the nanny who studied philosophy, or the musician who would break glasses when he was excited. And not forgetting Poppolino the monkey, who wore velvet jackets and argyle sweaters and was fond of listening to the radio.

Summers, though, belonged to the islands. For generations the Janssons came out to the Pellinki archipelago of Finland. Even here, Viktor would often be sculpting his life-size, sometimes mythological figures or portraits, while Ham would make her fine line drawings. Only when the ink was dry on Ham's drawings, and they had been sent to the publisher by the herring boat, would she join the children for a swim. The children were left to roam about and, with Tove as a guide, they found adventure in the smallest of things: a whole world could be observed in a rock pool; flotsam and jetsam became their treasure.

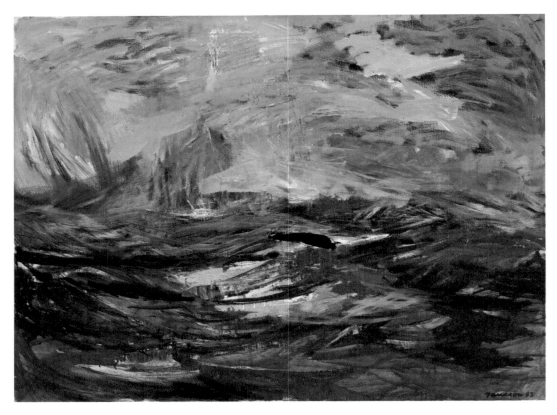

Abstract Sea, 1963

Tove was always creating something—edging flower beds with pearly shells or arranging wild mushrooms into a colorful bouquet. She drew her first Moomin here: a peculiar, round little creature with a large snout. It looked something like a fairytale hippopotamus. She scribbled it on the wall of the outside bathroom to make the others laugh. No one would have guessed that this little creature would one day make her world-famous.

Tove had started drawing before she could walk, her parents used to say. As a toddler, she would sit beside her mother for hours and watch her draw, then she would make her own pictures. By the time Tove was a teenager, her first drawings had appeared in a magazine, and by nineteen her first storybook was published.

She studied art in Sweden, then Helsinki and Paris. She loved the vibrant artworks of Impressionist painters like Matisse. She painted modern self-portraits and light-filled landscapes with energetic brushstrokes and strong lines. But life was about to change for everyone.

On her return to Finland in 1939, the Second World War broke out. One of her younger brothers, Per-Olov, was sent to fight when foreign forces invaded the country. The family was scared because they didn't know where he was and when he might return. Tove poured her fear and frustration into her work.

Tove created a series of provocative caricatures of Hitler and Stalin for the magazine *Garm*, which she'd been working for since she was fifteen. As foreign forces invaded the country, it was a risk to express her opinions. She imagined a strange but parallel world, in which a family of peaceful creatures—the Moomins—are forced to leave home when a great flood threatens their beautiful valley.

The characters in Tove's books were recognizable. Moominpapa was like Viktor—always keen for adventure. Moominmamma was Ham, of course: unflappable and the most loving mother you could imagine. Moomintroll was a bit like Tove herself. How about the tiny, independent, fierce Little My? Well, she could say all the terrible things that Tove would never dream of saying in real life, but probably wanted to. Moominvalley was like all the best parts of the beautiful islands.

Alongside her stories, Tove continued to paint. She created huge, beautiful murals for the city of Helsinki, including religious altarpieces, and had exhibitions of her work. In 1952, after her first two books were published, the London *Evening News* asked her if she would create a comic strip from her stories.

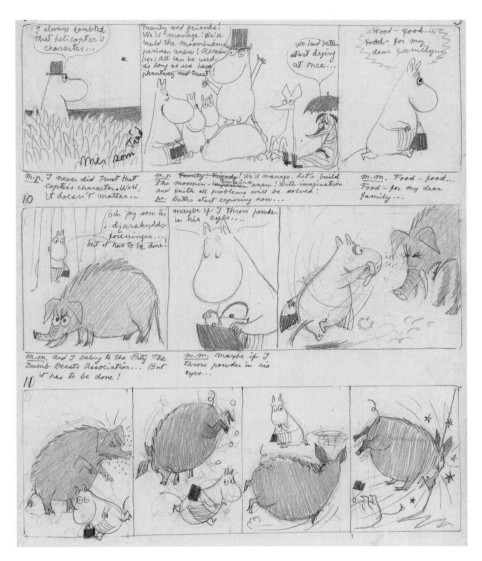

Sketch for the book *Moomin's Desert Island,* 1953–59

Tove had been finding it hard to support herself as an artist and had been selling her drawings in exchange for heating fuel, so of course she accepted. Before long, her comic strip was appearing in newspapers across the world. The Moomins became a phenomenon. They said she had twelve million readers! But the success took over Tove's life. She spent every single day creating new stories and personally answering every fan letter, of which there were thousands a year.

By the time she met Tuulikki Pietilä, who was an artist, too, she was unhappy. She felt trapped by the imaginary world she had created, with no time to do the painting she longed to do, or enjoy these islands and nature as she always used to. Tuulikki—or Tooti as Tove called her—appeared like a ray of sunshine.

Back in 1950s Finland, for a woman to love another woman was illegal. But on the islands, there was no one to tell them what to do: they could live and love as they wanted. They built a home out of driftwood. It was swept out to sea. Undaunted, they built a stronger home on the island of Klovharu. It had no running water or electricity, but they spent every summer there for nearly thirty years.

Now Tove is no longer with us but, years later, all of Finland and much of the world still celebrate her. She left us with a wonderful lesson: be brave, enjoy each other, love whomever you choose, dance, wear flowers in your hair and always, always live in peace.

Frida Kahlo

"I never painted dreams. I painted my own reality."

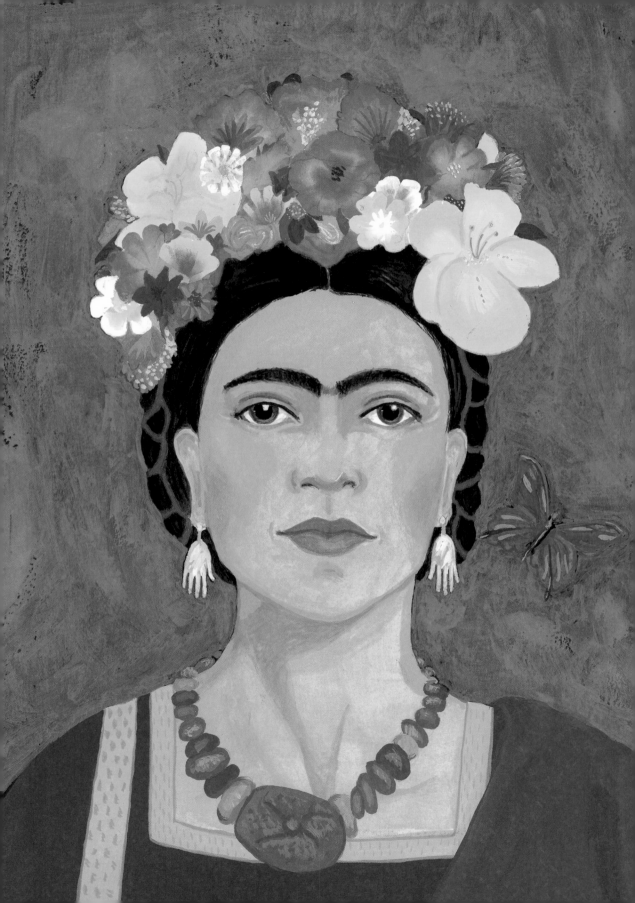

Frida Kahlo

Portrait of Reality

The stage was set. The audience quieted. As the curtain rose, the violins, flutes and oboes began to play. The opening melody of the opera filled the theater. But then, suddenly, a noise stopped the orchestra. All eyes turned to the balcony and watched as an unmistakeable figure made her entrance. Her thickly-braided hair was dressed with fresh flowers. Her eyes sparkled as brilliantly as the jewels that she wore. She looked as regal as an empress. The auditorium held its breath. She settled in her seat, and the music began again. That night there were two performances: the opera on the stage and the living masterpiece that was Frida Kahlo, up there in the balcony.

Frida's home, La Casa Azul, was blue on the outside, and blue on the inside. There were monkeys, parrots and a little deer, and all the plants grew with complete freedom. Her garden burst with color. Inside, the walls were decorated with Mexican folk art and retablos—small religious paintings that often hung in churches, depicting stories of people who have been miraculously healed. If only Frida could have been healed like them.

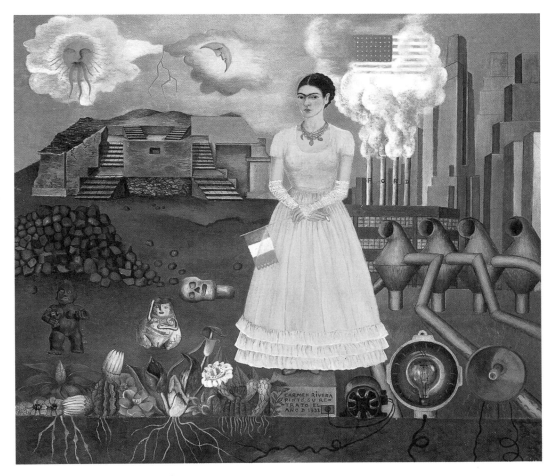

Self-portrait on the Borderline between Mexico and the United States, 1932

Her troubles started when she was six. She was stricken with polio and was kept to her bed for nine months. The disease left her with one leg as thin as a straw. Once she had recovered, Frida's father encouraged her to play rough games, like wrestling and soccer. She loved the feeling of becoming strong, of being able to do all the things that the boys could do. She started wearing suits and ties. People thought she was strange, dressing as a man, but Frida never worried about what other people thought.

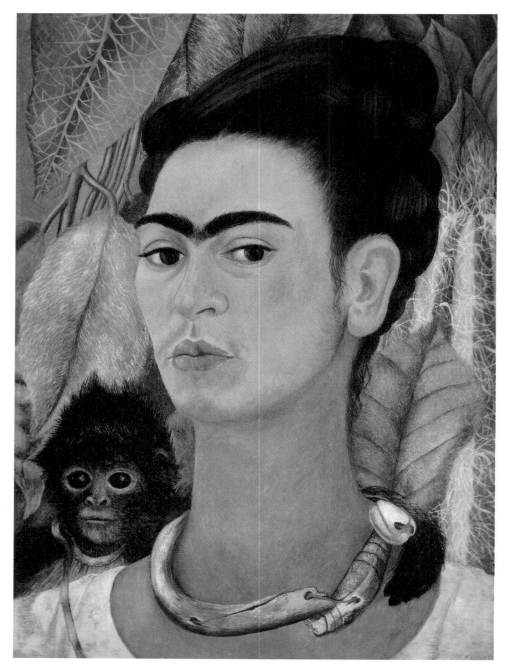

Self–portrait with Monkey, 1938

Frida became one of the few girls allowed to study at the Preparatoria—the finest school in Mexico. She had a gang of friends, mostly boys, who were clever, but mischievous. One day they let a donkey into a classroom as they thought the teacher was too boring. The games did no harm. And how Frida laughed! At school, she hadn't wanted to be an artist. Frida's first ambition had been to become a doctor. Her studies of medicine and botany later found their way into her paintings as intricate close-ups of flora and fauna, which she had been so fond of.

She was eighteen when the accident happened. She had climbed aboard the bus from school as usual when a tram hit. They say it didn't stop. It just kept going, slowly, but powerfully. And the bus kept buckling. Many people died that day. The metal handrail had gone right through Frida. Almost every bone in her body was broken. One of the passengers had been carrying a package of gold leaf to decorate the new national theater. The package exploded with the impact and showered Frida in gold as she lay in the street. At first, they thought Frida was dead, too. They thought no one could survive injuries like that.

For a year after the accident she couldn't move. Her mother positioned a mirror over her head and her father, a photographer, lent her his old kit and made an easel for her bed. Painting became a way to relieve her boredom and she began to paint herself. Soon, her self-portraits became her obsession: a distraction from the pain.

She painted things as she saw them, with each painting becoming more revealing and intense, many featuring her favorite pets. In some ways it was like a resurrection, for she felt, the Frida she once was no longer existed. But she was still alive, and she would keep on living. It was some kind of miracle, but she was like a phoenix rising from the ashes.

When she was strong enough she took a couple of her pictures to her friend Diego Rivera. He was a famous Mexican painter who had spent many years in Paris, and was friends with other artists including Pablo Picasso. Diego thought the canvases, like the girl who brought them, were extraordinary.

Mexico had just emerged from ten years of war and revolution, and there was an outburst of creativity, celebrating modern Mexican art, film and philosophy. Talented people like Diego were creating a vibrant new national identity and Frida wanted to be part of it too. She had a revolutionary spirit and wasn't afraid to question the world around her. While Diego's artworks were filled with grand political themes and painted on a big scale, Frida's were small, intricate and personal.

Frida and Diego married and, although they had a turbulent relationship, they continued to support each other's work. In late 1930, they moved to America, where they had become famous.

Frida was friends with great artists, political exiles and philosophers. She held exhibitions in New York and Paris, and was one of the most photographed people of her time. Some people thought that her work was similar to the art of the Surrealists, who created bizarre images combining fact and fantasy. Frida, though, painted her own reality. She never shied from personal subjects and through her paintings she showed her own pain.

Throughout her life, Frida had many operations, and grew weaker day-by-day. Her back was so fragile that she had to wear metal and leather corsets or plaster casts around her torso. Yet she was never one to let these things break her. The casts became canvases on which to paint. She challenged the thought that those who were frail in body were weak in spirit. The flowers in her hair, the jewelery, the colorful traditional Mexican dresses that swept the floor, they all disguised her fractured body. But as she listened to the opera and gazed down—still smiling despite all the traumas she had faced—she was a compelling reminder of the strength of the human spirit.

Corita Kent

"Not all of us are painters but we are all artists.
Each time we fit things together we are creating."

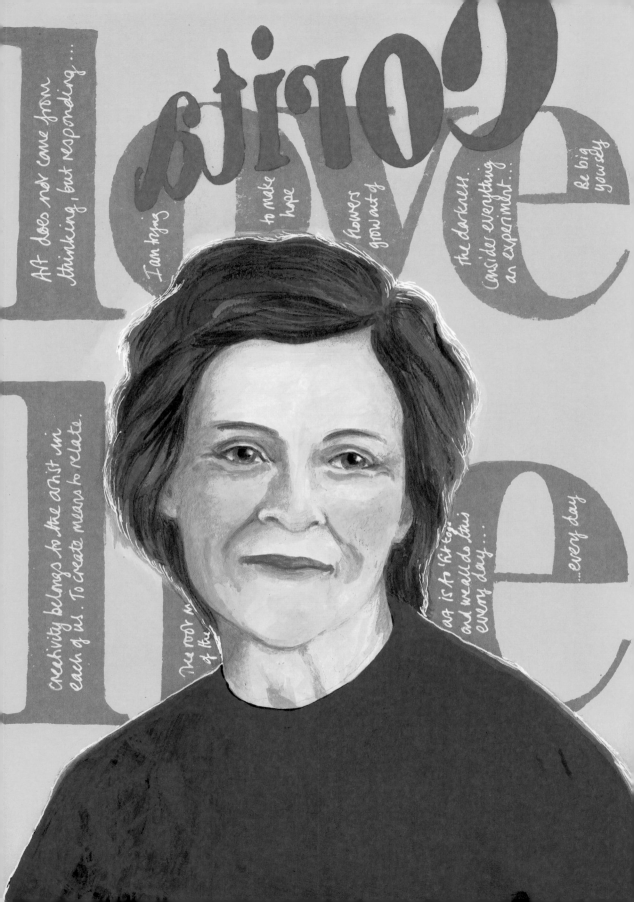

Corita Kent

Pop Art with Heart

The Hollywood parking lot was busy and dusty. Heat rippled off asphalt. Cars and trucks rumbled past, gears grinding, horns blaring. Music drifted from open windows as traffic lights changed. The rebel nun stood in the midst of this noise, dressed in her black and white robes. She gazed up at the colorful signs filling the sky, vying for attention.

Artists find their inspiration in all kinds of places. The out-of-town urban landscape, crowded with advertising and signage, may seem ugly to some, but for Sister Corita, it was an exciting and stimulating place to be.

Corita Kent was eighteen when she became a nun. She had been born Frances Elizabeth Kent into a large Irish Catholic family in Iowa to whom religion was very important. In 1936, after completing school, she joined the Immaculate Heart of Mary religious community in Los Angeles and chose a new name—Sister Mary Corita—and became known by everyone as Sister Corita.

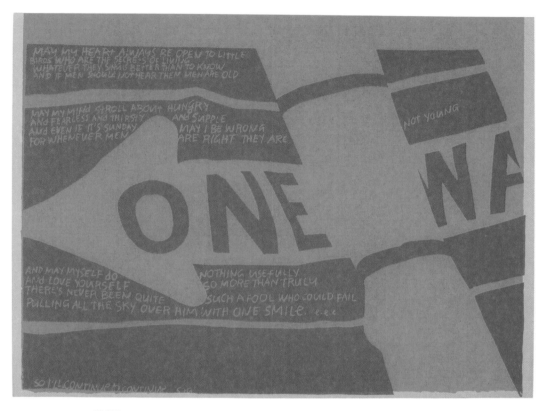

one way, 1967

Becoming a nun was a huge decision. In the 1930s, being a nun meant giving up your birth name, your independence, freedom of thought, your love life and your individuality. Nuns wore traditional starched uniforms called habits, showing only their faces and hands. They promised absolute obedience to the church and its leaders.

But the nuns of the Immaculate Heart of Mary religious community and college were energetic. They weren't afraid of trying new things. During the 1950s the college was celebrated for being forward-thinking. In 1962, when the leader of the Catholic Church, Pope John XXIII, made a rule calling for the Church to become more modern, Corita and the sisters saw it as an opportunity to finally be seen and heard.

That same year, Corita visited an exhibition by the famous pop artist, Andy Warhol. She had been working at the college as an art teacher and experimenting with serigraphy, or silkscreen printing, for some time, but Warhol's paintings of soup cans changed her view of art completely. "Coming home," she later said, "you saw everything like Andy Warhol." Back in the college studio, she rolled up her sleeves and began a new series of artworks that would propel her from being an ordinary convent school art teacher to a famous artist.

Corita's prints were risky and full of bold, clashing colors. She used advertising slogans, song lyrics and the everyday language of the city alongside stories from the Bible and quotes from books to create vibrant artworks that spoke out against poverty, war, racism and injustice. She was an activist as much as an artist; her artworks were messages about how we might live and how to care for one another. It was pop art with heart. "I hope [my art] will give people a lift..." she said, "more fun out of life."

Although Corita called herself a teacher and printmaker, she was so much more. She created public artworks, including a mural for the Vatican Pavilion of the 1964–65 New York World's Fair, which was a huge honor, and organised "happenings" where people came together to have fun with art. She made her art easily available and put it on prints, posters and greeting cards that were sold in churches, community centers and at fairs, as well as in art galleries and businesses.

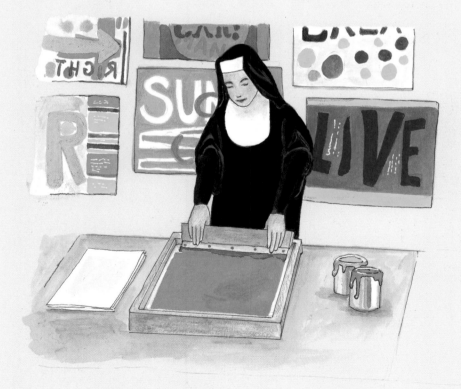

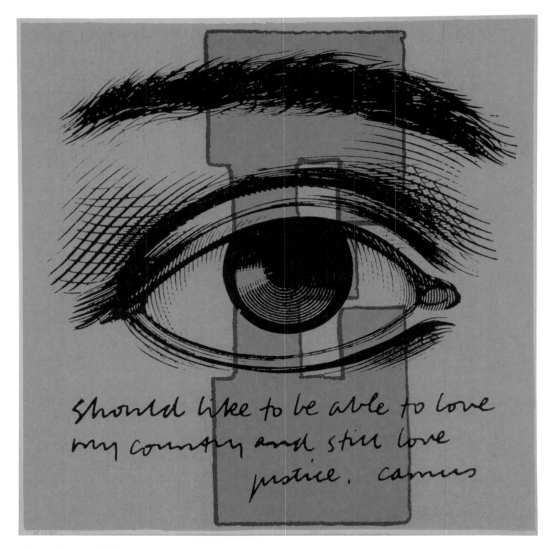

E eye love, 1968

But not everyone appreciated her art. Some church superiors thought it was dangerous. They could not understand it—it was too modern, too clever, too outspoken. They were unsettled by her fame and thought that she was getting too big for her britches. Nuns, they thought, should live in quiet devotion. Corita was told she must stop making such sensational art.

Corita laughed away the criticism and kept going. But eventually the pressure to conform, the demands of teaching, speaking and celebrity became too much. She took time out. Although the Immaculate Heart Community had been her home for most of her adult life, she chose not to go back. Instead, she focused on simply creating art.

Although she would never enjoy the same superstar status during her lifetime as some male pop artists, Corita still made an impact. She was featured on the cover of national magazines as an icon for the "modern nun," and when in 1985 the U.S. Postal Service published her Love stamp, they sold 700 million copies. For Corita, it was important to be her joyful self, no matter what anyone else said. As she often told her students, "Don't belittle yourself. Be BIG yourself."

Emily Kame Kngwarreye

"Whole lot—that's what I paint, whole lot."

Emily Kame Kngwarreye
Dreaming

Emily was in her favorite spot with paint pots lined up beside her. She was humming while making strokes with her stubby brush on the huge piece of canvas laid out on the red earth in front of her. Colors flowed and multiplied, in some places they looked like branches or roots. Her paintings, she said, tell the whole lot. She meant that they speak of her life and the land.

In the Northern Territory of Australia, the ground was dry and cracked. Sometimes it didn't rain for years. It was harsh but the Anmatyerre people knew how to survive. They had done so for hundreds of generations. They knew how the plants grew, how to find the delicious yam roots that hid underground. They were taught these things through the Dreamings—stories of their ancestors. This was Emily's home.

Emily never knew the year she was born. But little things like that didn't matter to her. Many years later, Emily would become a tribal elder in her community, making her a keeper of these stories.

She had learned a long time ago to create ceremonial sand paintings that described the Dreamings. She had the honor of painting the patterns on the bodies of the women when they had a ceremony called Awelye. But she was nearly eighty years old when she made her first painting! A bit late in life, you might think, but she said the paintings came when they needed to. She worked in batik-making first—a way of painting on fabric using hot wax and dyes. She never liked the smell of the wax fumes, so when paints and canvases were brought to her community, she was more excited than anyone.

For Aboriginal people, the Dreamings explain how the spirits created the land and everything in it. When Emily painted the Dreamings, it looked as though she was creating a picture of the entire universe: from the stars down to the tiny cells within us that we cannot see.

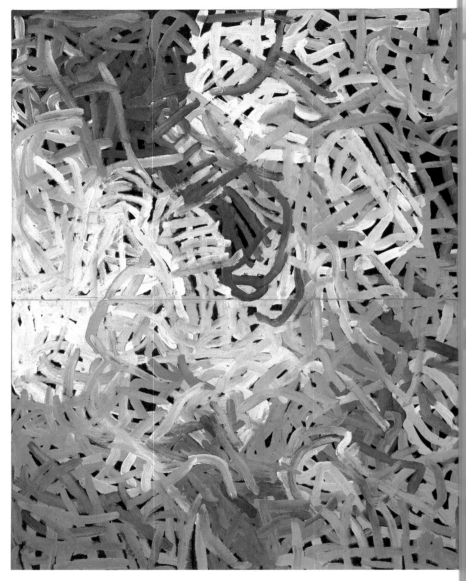

Anwerlarr angerr (Big yam), 1996

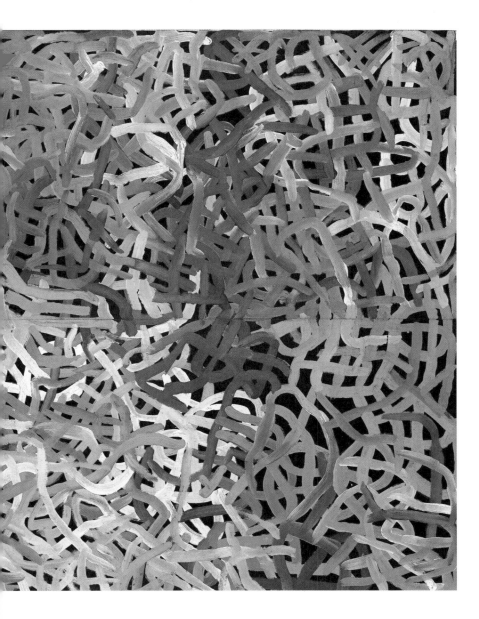

The spirits in the Dreamings created the seeds,
the plants and the soil. They gave life to the ancestors.
They shaped the big sand hill uturupa that gave this
place in the desert of Australia its name: Utopia. The word
Utopia means "a place in which everything is perfect."

And it was as though the paintings flowed through Emily. Everything that she was, everything that she loved; all that is ancient and wise poured out of her and onto the canvas. Strokes covered strokes, until there were layers upon layers of color. If you looked at them for long enough you felt as though you could fall into them.

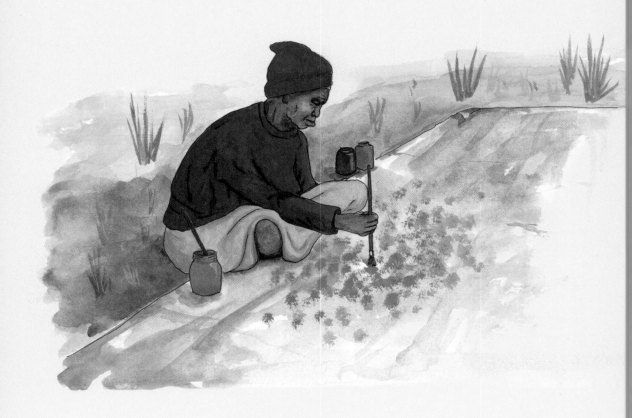

Even though she was one of the oldest in her community she had such energy. She painted nearly 3,000 paintings in eight years, some of them so big they were twice a man's height!

Some people compared her art to great artists like Claude Monet or Jackson Pollock, but Emily had never seen any art from the outside world. She painted what she saw and what she dreamed. She became the most famous indigenous artist in Australia. She was known all over the world. But she shared the money that she earned with her people.

Emily lived a traditional Aboriginal life. Sometimes she gathered bush tucker—that is what naturally growing food is called when it is found in the wild, like seeds and fruit, witchetty grubs and honey. She liked to sleep under the vast desert sky. She felt the earth, whispered to the ancestors, and then she dreamed. She dreamed of flying above the wild country, she dreamed of lizards and emus, sacred grasses and ntange seeds scattered by the desert breeze across the plains.

She dreamed of gliding under the earth between the long, twisting roots of the yam: the sacred yam that grew above and below ground, as if it connected the earth with the spirits. She dreamed, then she painted, the whole lot.

Yayoi Kusama

"I create art for the healing of all mankind."

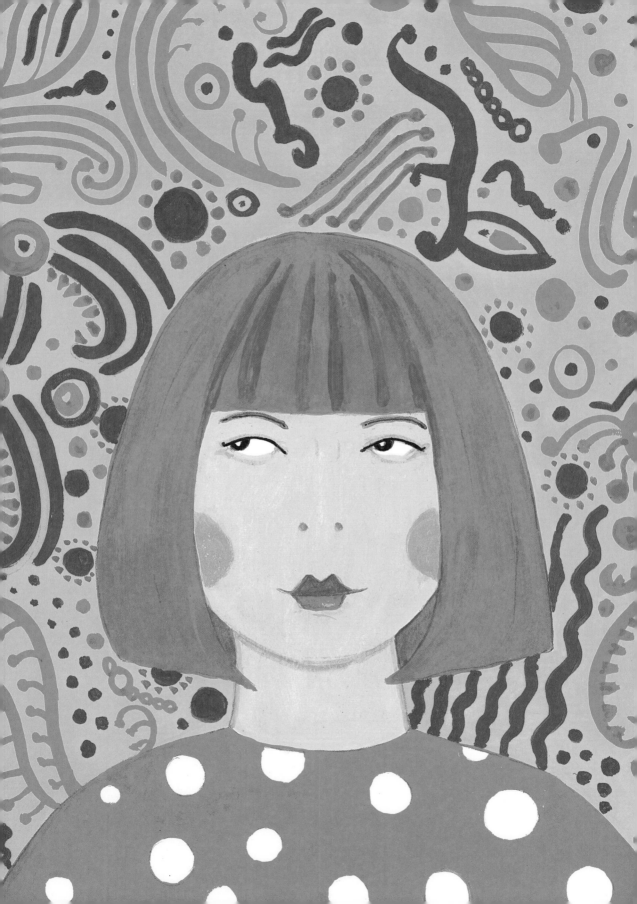

Yayoi Kusama

A Dot in the Universe

Sunlight streamed through the window. Outside the city was waking up. The streets of Tokyo were filled with noise. Everyone was rushing. Everyone was busy. But Yayoi was not part of it. This was her sanctuary, her refuge. Near the hospital was her studio. Yayoi needed to make art. It is not only something she loved doing, it was also a form of medicine.

Today, her work is known across the world, but Yayoi didn't have an easy start. As a child, she drew every day. But her mother was very traditional and disapproved of Yayoi's dream of being an artist. She told her daughter that one day she would have to marry someone from a rich family and become a housewife. She took away Yayoi's inks and tore up her pictures. This made Yayoi all the more determined!

When she was older she wrote to the artist Georgia O'Keeffe asking for her advice. An artistic life was hard anywhere, she said, but she would help Yayoi if she could. Encouraged by Georgia's letters, Yayoi filled a suitcase with her drawings and paintings, sewed some money into the lining of her clothes and left Japan.

No. F, 1959

When Yayoi first arrived in New York City in 1958, she went to the top of the Empire State Building. All the people looked like tiny dots from above. She promised herself there and then that one day she would make her name as an artist. She knew she could do it. She had a volcano of creative energy inside her.

Yayoi found a small studio, and made herself a bed from an old door. What little money she had, she spent on art materials. When she ran out of food she scavenged for scraps of vegetables and fish heads in trash cans, then made them into soup. Sometimes she couldn't sleep because she was so cold and hungry. But she always found a way to survive and make art.

Yayoi began painting white loops, made up of multiple dots and repeated patterns, on a black background, which she called "Infinity Nets." She painted from dawn to dusk, sometimes through the night, too, without stopping. The "nets" had no center, no perspective.

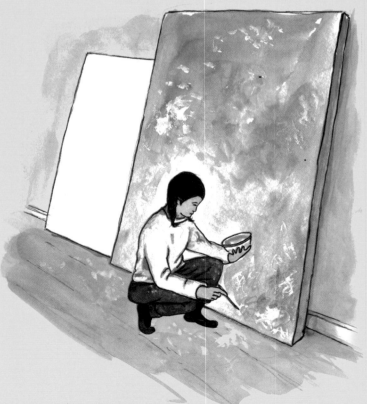

When she was painting, the pattern seemed to creep outside the canvas to fill the floor and the wall. They were patterns to become lost in. Some of the canvases were over thirty feet long. Her desire was to try to imagine and measure the vastness of the universe and her own place in it.

New York was the center of the art world in those days. Artists including Andy Warhol and Donald Judd were creating completely new forms of art, like pop art, which used comics and advertising as inspiration, or minimalism, where the art does not represent anything: the viewer sees or responds to it however they choose. Even though art was changing in exciting ways, the most famous artists were men. It was going to be difficult for a young female Japanese artist to make her mark.

Soon it was the 1960s and everything was changing: fashion, music, art. Yayoi used them all for inspiration. She made sculptures, like a rowing boat filled with soft, sewn sausage shapes that looked like body parts. She made clothes using dry macaroni. She posed naked in photographs. She rode a horse covered in dots around many parks, and created "happenings," where people took their clothes off in the street and danced around while she stuck polka dots onto their skin.

Why the polka dots? For one hundred years Yayoi's family had run a seed plantation, so she grew up surrounded by fields of colorful flowers. One day, when she was about ten years old, she was walking near her home. She looked up to find that each and every violet had its own individual, human-like facial expression and, to her astonishment, they all seemed to be talking to her. Then she saw dots and patterns. They seemed to come from nowhere; they came alive, and covered everything. Her art became a way of recording and understanding these overwhelming experiences, called hallucinations.

She worked day and night on her artworks, but creating so much art eventually left Yayoi exhausted. Even though she was becoming more well known in America, her mental health was suffering. She returned to Japan in 1973 and checked herself into a hospital. With art therapy, she realized she could translate her hallucinations and fear of them into paintings, her sculptures and all of her creations. She could create environments in which others could be immersed in her art, and in her inner world.

Now people come in the thousands to visit her Infinity Rooms. There, space becomes never-ending. When you are inside you'll soon realise we are all just a single dot in a vast universe.

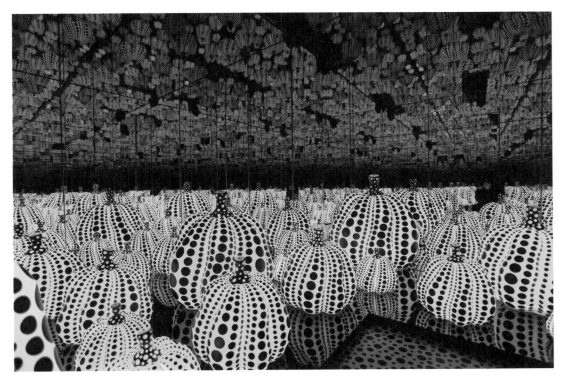

All the Eternal Love I Have for the Pumpkins, 2016

Gabriele Münter

"When I begin to paint, it's like leaping suddenly into deep waters, and I never know beforehand whether I will be able to swim."

Gabriele Münter

A Blue View

It was the thing she feared most: soldiers thumping at the door. Bang. Bang! They had purpose and intent. How it made her heart race. Again and again she imagined opening the door and seeing the smart uniforms and the eyes like steel. She would offer them tea. Each time they would push past her, overturning furniture, searching. They would never find anything, of course. They would finally leave with Gabriele sitting in the mess of her room. Every time she thought of it her hands would tremble in her lap.

Gabriele's passion was creating works of art. Theirs seemed to be destroying them. The National Socialists thought that if a painting didn't look the way they wanted it to look then it should be burned. But Gabriele never created art for anyone else. And she wouldn't ever have thought of changing the way she painted because of a few bullies, even if she had to live with the fear of being raided.

Gabriele started drawing when she was a young girl in Germany. She didn't dare to think she could be an artist though. In those days girls were not allowed to attend art academies in Germany. Gabriele's father believed everyone should have the same chances in life and that girls should be able to do what they wanted, but he died when she was nine. Her mother arranged for her to have private drawing lessons with a very skilled artist called Mr. Ernst Bosch. But simply drawing detailed harvest scenes felt restrictive to Gabriele.

Then, when she was twenty-one, her mother died too. In 1898, together with her sister, Gabriele went to America, where one of her relatives gave her a Kodak camera. She thought it was like a magical box! It was tricky to work out at first, looking down into the viewfinder and holding the box at her chest, but she got the hang of it soon enough. The joy of suspending a moment of time in an image, well, it changed everything for her.

It wasn't until 1902 that Wassily Kandinsky, a Russian artist and teacher at the Phalanx private art school back in Munich, encouraged Gabriele to paint freely. He had told her that as a pupil she was hopeless! But he also told her, "All I can do for you is protect your talent and take care that nothing wrong becomes added to it."

Kandinsky taught her about color, and how to use it well in her paintings. He could see music in color and he taught her how red was alive and restless; green was calm and still; yellow was exciting! Gabriele couldn't wait to paint more, to paint faster! Kandinsky taught her how to use a palette knife instead of brushes, which meant that she could apply the paint much faster and to great effect.

They began painting together in the Bavarian Hills. Their evenings filled with art, love and politics. Together they formed Der Blaue Reiter (The Blue Rider), a group of artist friends who, like them, wanted to create something new, and express themselves in a different, more moving way. They were against the bourgeois society, which was all about greed and indulgence. They wanted their art to show their own view of the world, about truth and their own idea of beauty, which was about simplicity and innocence. Their rebellion was quiet and clever. Their art shocked those who were used to art being grand, opulent and safe.

Gabriele once wrote of her time in Bavaria and the way the landscape had inspired her to create. It had been a warm summer's evening and she had been walking alone. The wildflowers were nodding sleepily, insects chirped and droned. Ahead was a small inn, with a path rising behind it.

Mai-Abend in Stockholm, 1916

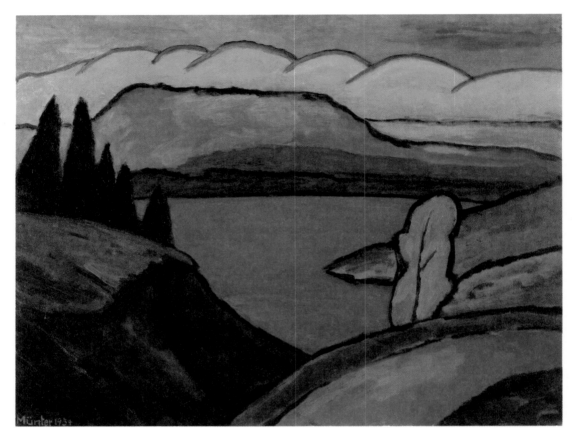

The Blue Lake, 1934

And there, in the distance, a blue mountain soared, kissed by red-blushed clouds. She quickly painted the scene, that fleeting moment. And then it happened. It felt as though her heart was bursting open, as though she was a bird in song.

Gabriele believed that colors could carry emotional weight. She layered them to create complex tones and show different visual effects. Here was a colorful voice of her own, and it was as bold as anything, painted in bright colors and simple shapes: *The Blue Mountain* (1909), she called it. She had found her artistic voice.

With the outbreak of the First World War, Kandinsky was forced to leave and continue painting in Russia. When the Second World War broke out, Gabriele feared for the safety of the paintings by Kandinsky and Der Blaue Reiter. She hid them in her home, knowing that she could be arrested if they were discovered. They remained hidden until it was safe for them to be seen again. As for Gabriele, it was years before she began to make art again. When she did, she brought vibrant landscapes to life, experimented with realism, abstraction, folk art and portraiture. For Gabriele, creating art was a way to explore her ideas about the world, a way to make her heart sing.

Georgia O'Keeffe

"I found I could say things with colour and shapes that I couldn't say any other way—things I had no words for."

Georgia O'Keeffe
Mother of Modernism

Georgia smiled. She was in the Black Place. Here, in New Mexico, the rocks rippled and flowed, dark and brooding. Other people might not have seen any beauty in it at all, but she thought it was magnificent. To Georgia, the rocks were not just black, they had shades of rust and violet and ash in them. She would spend days and days painting this place, and never tire of it.

From an early age, Georgia knew she wanted to be an artist and was encouraged by her high school teachers in Wisconsin. Her art teacher was a thin, bright-eyed woman who always wore the same hat, crowned with imitation violets. Even many years later Georgia remembered how her teacher pointed out the violets' curious shapes and variations in color: the deep, earthy mauves and purples, the infinite variety of greens. Georgia had never looked at something so closely before, and the idea of trying to paint the flowers intrigued her. From that moment on, she could not help but look very carefully at the details of things and recreate them later in her paintings.

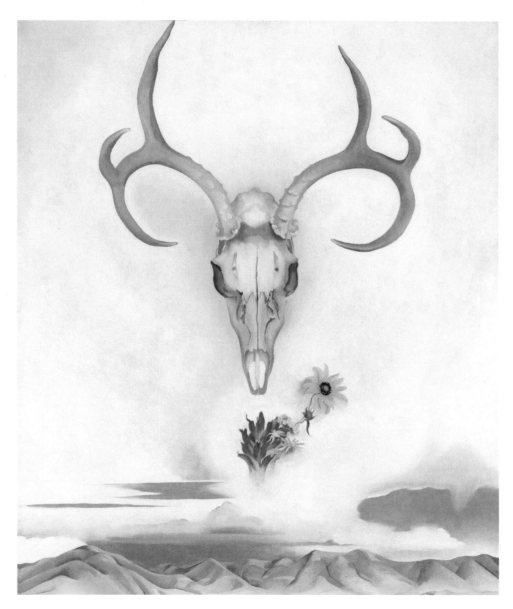

Summer Days, 1936

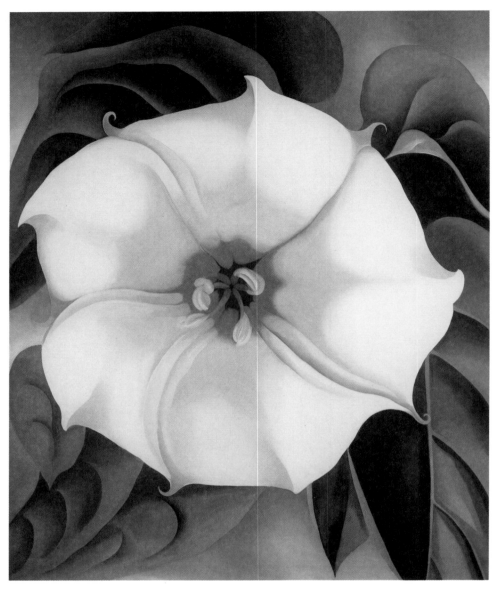

Jimson Weed/White Flower No. 1, 1932

She went to the Art Institute of Chicago to study in 1905 and, when she finished, took teaching jobs in South Carolina and Texas. She found herself in a harsh landscape, where the sun blazed in the summer and where the winter could freeze you solid. She loved it all. The wildness of nature thrilled her.

Her urge to paint was still strong, but she wanted to do the opposite of what she had been taught. As an experiment, she banned herself from using color. Using charcoal, she sat on the floor of her room day-after-day, trying to capture something of her feelings, her true self. Eventually, after a couple of months of frustration, she felt a new freedom in her work. Her pictures were filled with abstract forms that suggested the swirling of flames or the vitality of tender new shoots.

In 1912, during her summer school art course at the University of Virginia, she had become interested in the revolutionary ideas of Arthur Wesley Dow, a professor who encouraged artists to express themselves freely. Arthur had different views on composition, how artwork is structured on a canvas, and he believed that art should be a living force for everyone in everyday life, not just ornaments for a few. Georgia was inspired to experiment with these ideas.

She started painting flowers, but not as anyone had ever painted them before. "In a way, nobody sees a flower," she said. "It is so small—we haven't time—and to see takes time, like to have a friend takes time. I will make even busy New Yorkers take time to see what I see of flowers."

Georgia chose to paint what flowers meant to her, and painted them big. Her huge paintings intimately described the fragility and perfection of flowers. They bewildered critics. She painted so differently from other contemporary painters.

At first, people did not know how to react to Georgia, or her art. Even as a young woman Georgia had stood out from the crowd. Her eyes were clear and penetrating. With just one look it seemed as though she could see right through into your soul. She liked to wear black and wore a man's felt hat. In 1916, she sent her drawings to a friend, who secretly showed them to the famous photographer Alfred Stieglitz. Alfred thought they were extraordinary and hung them in his gallery in New York. It was the beginning of an amazing creative partnership and love affair.

By the 1920s Georgia had become one of the most respected artists in the world. She enjoyed her success, but disliked the bustle of the city, the fancy gallery openings and the parties. She was most at peace out in nature, alone with her easel and her paints.

In the 1930s, Georgia bought a tumbledown farmstead called Ghost Ranch on the outskirts of Abiquiú, New Mexico. About 150 miles northwest of there was Black Place, her favourite spot to paint.

Georgia worked in all kinds of weather; in wind so strong that if she got up from her stool it would blow away, or in a heat so powerful that she would have to crawl under her car when it got too hot. She created many masterpieces there; paintings that have inspired other artists all over the world. People call her the "Mother of American Modernism" for the bold style of painting that she pioneered.

Everything in New Mexico inspired her. She particularly enjoyed things that people might ordinarily overlook, such as a door set in an old wall, or a humble flower. Sometimes she tucked pink and white flowers behind the horns of a cow's skull, or balanced huge bones on their side, allowing them to become a natural frame to the desert landscape and sky. Some people might find these things frightening or even repulsive, but in her paintings they became beautiful.

"It takes courage to be a painter," she admitted. "I always feel I have walked on the edge of a knife ... but I would always walk it again. I'd rather be doing something I really wanted to do."

Lyubov Popova

"Most important of all is the spirit
of creative progress."

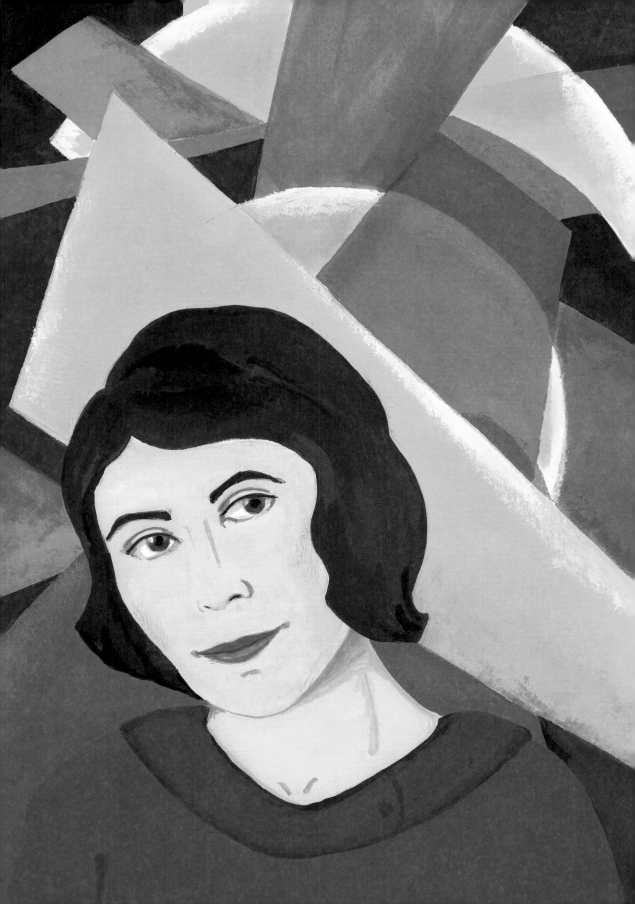

Lyubov Popova
Painting the Future

"The revolution is coming!""she heard people whispering as she walked home. She knew this already. It had been all her friends had been talking about for months. "Yes!" she said laughing once she was safely inside. "Yes, the revolution is coming. What a wonderful world it is going to be!"

For Lyubov and her friends, the Russian Revolution in 1917 was not just about who was going to be their next leader, it was about a whole new way of life. Russia would be a place where everything was done differently, where everyone was equal. Imagine! A world in which the farms and the factories belonged to the workers; where you did not have to pay to see a doctor or go to school. A place where art and the theater would be for everyone; a place where women artists would be as respected as men. This was just the beginning of the Russian Revolution. A time when the Tsar (Russia's emperor) and the monarchy, would be brought down and a new Communist leadership would take its place.

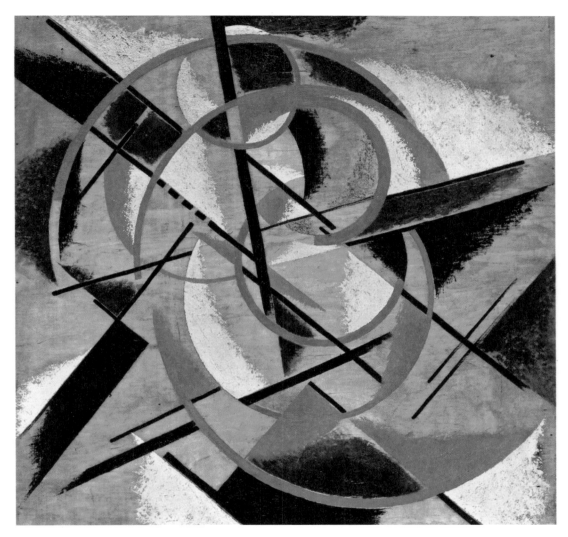

Space Force Construction, 1920–21

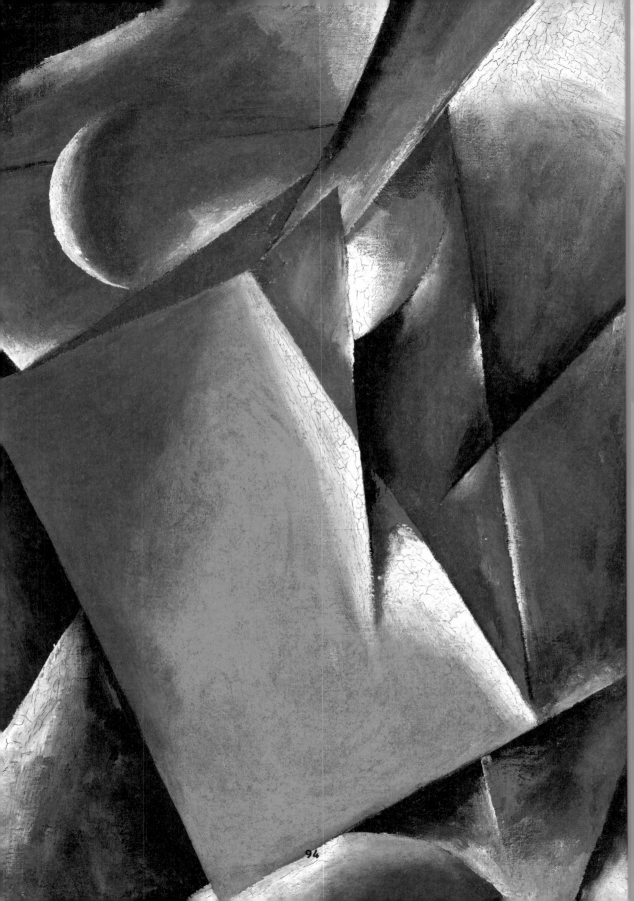

94

In Lyubov's apartment, paintings that burst with colorful and angular shapes filled the walls. Her travels in France and Italy in 1914, a few years before, had introduced her to the idea of Cubism and Futurism. Cubism with its geometric paintings and Futurism, which tried to capture the feeling of speed and technology, presented new ideas to Lyubov.

On her return to Russia she began to experiment and in 1916 she joined the Supremus, a group of Russian avant-garde artists, led by an artist named Kazimir Malevich. She wanted to express the tremendous changes happening all around her. She painted figures and still-life objects as if they were made from three-dimensional blocks and shapes, giving a feeling of energy and dynamism. Looking at her pictures was like looking at the world through a kaleidoscope.

Lyubov was among several avant-garde women artists in Russia, like Varvara Stepanova and Natalia Goncharova. They were gifted, inventive, and demanded that their voices be heard. They exhibited with famous artists from Europe and were respected for their dramatic artworks. And Lyubov's home was the place where these artists usually met. They often talked through the night.

OPPOSITE: Architectonic Painting, 1917

They believed the revolution would forever change art and its place in the world. It was up to them to help make it possible. They threw themselves into work, they designed posters and painted murals that supported the ideas of the revolution and an industrial and equal future.

To Lyubov and her fellow artists, the idea of painting at an easel was beginning to seem old-fashioned. There was a new way ahead. They would no longer paint pictures alone in their own studios: they would all work together, alongside architects, designers, and the leaders of the people. It was up to everyone to build this new nation.

There would be honor in creating something more useful. They would produce textiles and ceramics, design book covers and stage sets—they believed art should be practical and accessible to all. She and her friends called it "Constructivism." And Lyubov was at the center of it all, inspiring and demanding change.

OPPOSITE: Production clothing no. 1, 1921

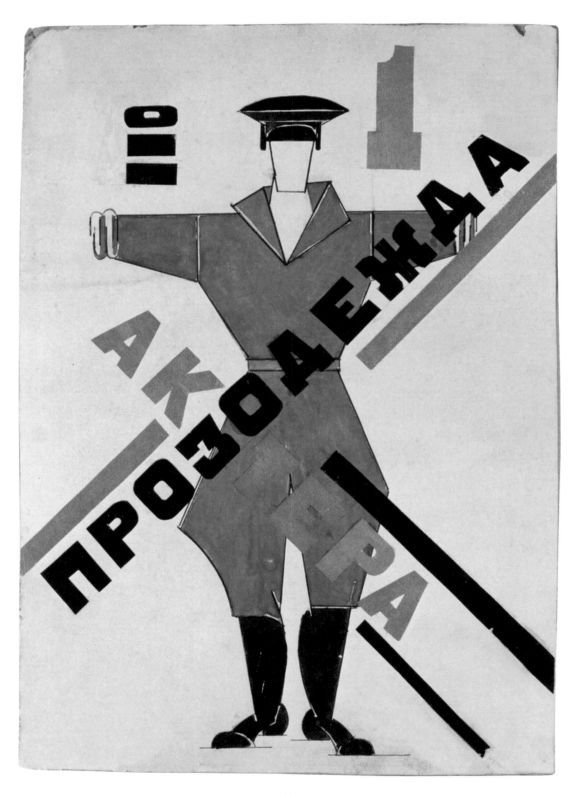

Faith Ringgold

"I have always known that the way to get what you want is don't settle for less... I always knew I would be an artist."

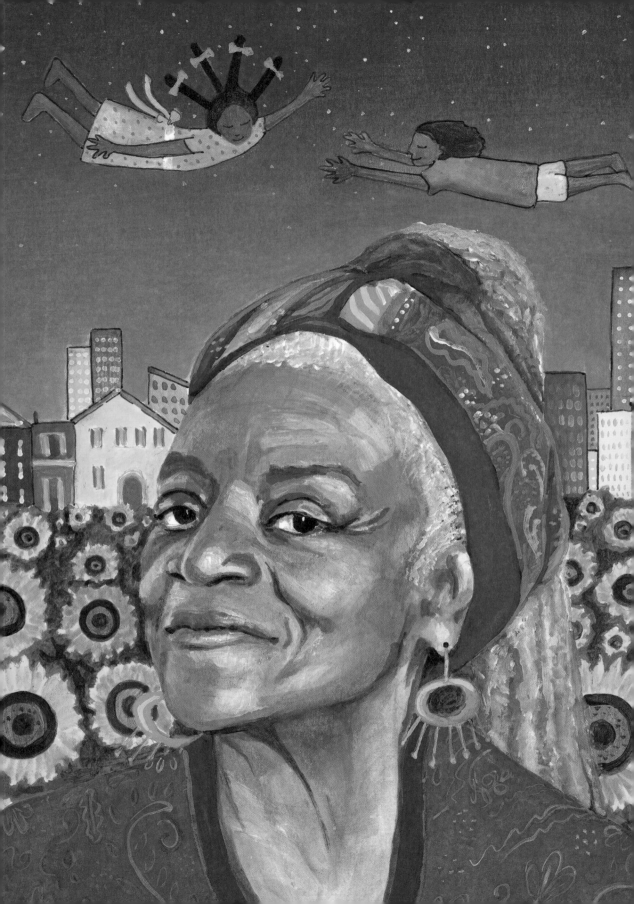

Faith Ringgold

Stitching History

They called it Tar Beach. It wasn't like any other beach you might imagine. It was a hard and black rooftop that gave off that warm and tacky smell of hot asphalt. Beyond was a noisy sea of skyscrapers, bridges and apartment blocks, with waves of taxis and cars stop-starting at traffic lights far below.

To Faith that rooftop in Harlem, New York, was as magical as any beach in the world might be. It was a place for dreaming. Faith and the other children would lie on a mattress on warm summer nights and gaze across the glittering city to the lights of the George Washington Bridge, while their parents sat around the old green table playing cards. Up there they felt invincible, like anything was possible. They would dream of flying, touching the stars that seemed to rain down around them. They could fly over any obstacle placed in their path.

In the 1930s, America was gripped by the Great Depression, so there wasn't much food to go around. Times weren't easy, but there was always something going on at Faith's house.

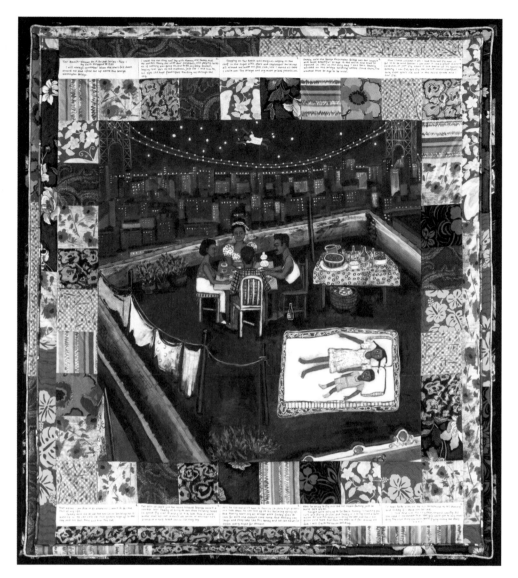

Tar Beach (Part I from the Woman on a Bridge series), 1988

Her mom, Willi Posey, was a fashion designer, and Faith's dad, Andrew, was always telling stories. People came and went constantly, chatting over tea and scraps of fabric.

Faith was curious and artistic and determined to make her mark. She couldn't go to school that much because of her asthma so she stayed at home with her mom, and was always coloring or painting something. But she knew, even when she was little, that she wanted to go to college. She was fascinated by the boys who streamed up the steps from the local subway station. One day she followed them. They were all going to City College. "I want to go there one day," she told her mom, "and study art." "Then you shall," Willi replied.

City College, Faith soon discovered, was just for boys. But she could always find a way around a challenge. After much persuasion, the Principal eventually agreed that she could attend as the only girl in the college and study to be an art teacher. As Faith said, she was allowed to do art but not be an artist.

Faith did become an artist, of course. But it didn't matter how good an artist she was, she was both African American and a woman. For centuries, African American people had not had the same rights as white Americans. The Civil Rights Movement had helped change this, and African American people were starting to be treated more fairly. But the art world was still dominated by white male artists. Faith heard that there was going to be a big art show at the famous Whitney Museum of American Art, but not a single African American artist was to be included. She was furious.

She came up with a plan. Faith and her friends would go to the opening, carrying whistles in their pockets, and blow them whenever the gallery staff weren't looking. They spread out and soon the gallery was deafened with the sound of whistles! Oh, it made the curators mad! They couldn't work out who was making the noise. The protest worked. Well, in part. Some African American artists were invited in to meet with the curators, but only the men. The women were left outside. Clearly, it would take longer for women artists to be seen. Faith's art was powerful, the in-your-face kind of art. But no one was interested in buying challenging art in those days. "What is it," she kept asking, "that makes women's art different from men's?"

Then, one day, she realized that she had always been surrounded by forms of women's art. Quilting and needlework had been a huge part of the lives of the women in her family. Right back from her great, great, great grandmother who, as a slave, had created quilts to keep her own family warm. Knowledge and tradition had been passed down from mother to daughter. And now, it was her turn. With her mother's help, Faith created her first art quilt. After that she created more and more.

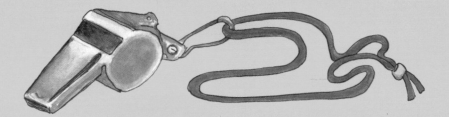

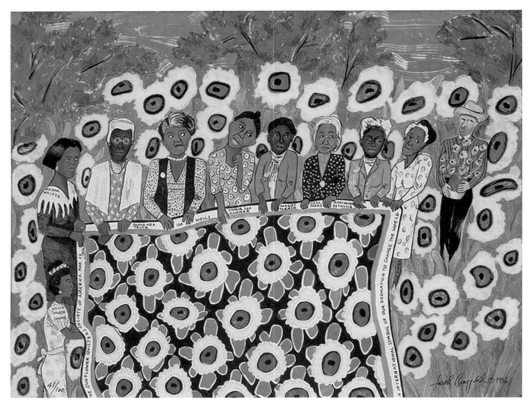

The Sunflower Quilting Bee at Arles, *1996*

Quilting, Faith realized, was a link to the women of her past, and a way to create a new form of art. It was also a way to create paintings as large as she wanted, and still be able to show them in galleries all over America. All she had to do was roll them up. She could take a whole exhibition in a single trunk! And you know what? Those people who hadn't looked twice at her first paintings began to take notice. Somehow the language of the quilt made it acceptable to be political.

Fifty years after the whistle-blowing protest, the Whitney Museum finally bought one of Faith's prints for their collection. Other great galleries and museums have her quilts too. Her artworks hang in the homes of presidents, and her mosaics line the walls of subway stations in New York City.

Faith has always wanted to change things. Not only has she created a new language in art, but she has written many children's books and started a foundation called Anyone Can Fly, which is devoted to teaching children and adults about African American masters of art. Her organization called "Where We At" encouraged other black women to find their own artistic voice too. "You can't sit around waiting for somebody else to say who you are," she said. "You need to write it and paint it and do it. That's where the art comes from. It's a visual image of who you are. That's the power of being an artist."

Amrita Sher-Gil

"My art is not my career,
it is myself."

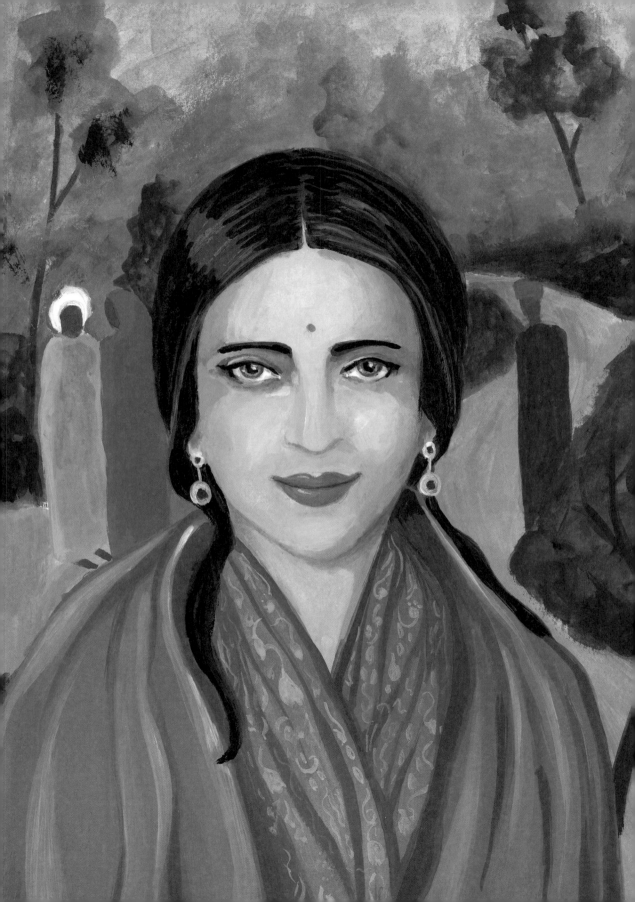

Amrita Sher-Gil

Color of Sunshine

Dust lifted off the track as they walked through the village. Heat rippled from the baked ground, making everything glow. It was no surprise that Amrita had come back to the village of Saraya, she had often talked about coming back to India when she was studying in Paris. To Amrita, the light in Europe seemed so gray. It made her feel dull and heavy. But in India the light spoke to her.

Amrita was a force of life. She had so much vitality, yet her paintings showed a different side of her. They were quiet and full of tenderness. Some thought they were paintings of sadness. She might not have meant to paint sadness — she just painted the reality that she saw. There was something about the hardworking people of rural India that struck her deeply. She explored the quiet corners of people's lives, particularly female emotions and the private world of everyday India.

OPPOSITE: Group of Three Girls, 1935

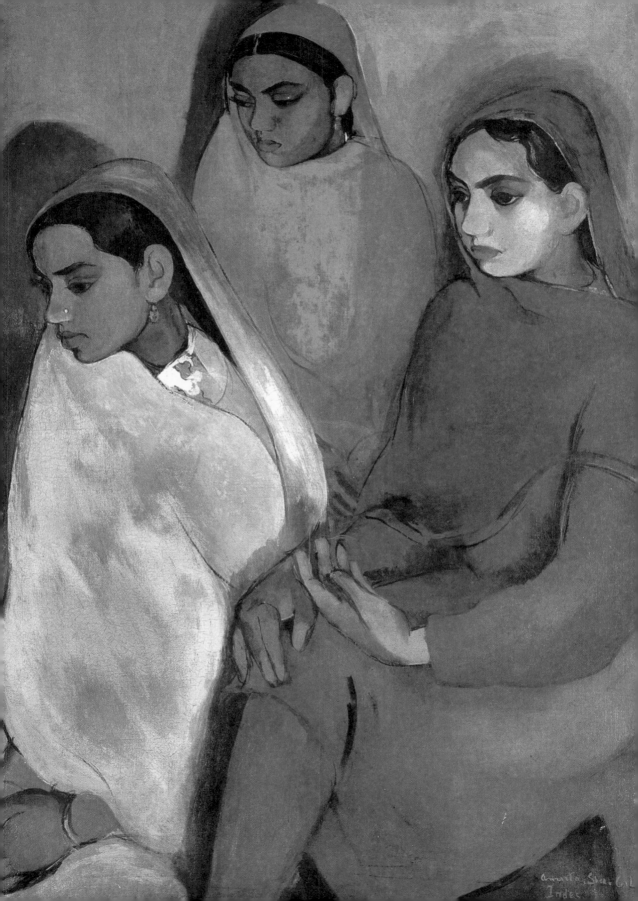

The scenes she painted seemed a long way from her own privileged life. Amrita had been brought up with every advantage. She had been born in Budapest, Hungary, then moved to India when she was eight. Her mother was a Hungarian opera singer, and her father, a Sikh from North India, was an aristocrat and a great photographer. Their home was elegant, their friends many. The family knew early on that Amrita would be an artist. She had started drawing at five years old, illustrating the folk tales that her mother told her. When she was sixteen, she went to Paris to study art at one of the finest schools.

Amrita was naturally gifted, but she also worked harder than anyone. Her sister, her cousins and friends became her subjects. She painted them all! Three years after studying in Paris, she became the first Asian woman to win gold at Paris's Grand Salon in 1932. It was a huge achievement. Yet Amrita was conflicted. She felt her Indian heritage was a part of her identity that was unexplored in her art so she went to India where her work might develop.

At the time, Indian art was all about landscapes or traditional mythology. Visiting artists from the west saw only the privileged, colonial side of India—to them it was all elephants, silks and glamour. During her time in India she was particularly inspired by the Bengal School of Art. Their focus was on creating art that represented India's indigenous heritage. It was a way of resisting British colonial rule. In 1936, she travelled through the vast country and met a great many villagers and women whose everyday lives she captured in her paintings.

Amrita combined the western techniques she had learned in Paris with the colors and heritage of India. She had a thirst for color and here it flourished. "In Europe the colors are pale—everything is pale," she once said. "You know, the color of the white man is different from the color of the Hindu. The sunshine changes the light. The white man's shadow is bluish-purple while the Hindu's is golden-green. Mine is yellow. Van Gogh was told that yellow is the favourite color of the gods and that is right."

She developed her own, unique style. There were camels, cart drivers, servants, tribal women, and women taking care of children. It was as though you were glimpsing a private moment in the lives of those she painted. Her paintings were beautiful, yet haunting. "I am trying to be," she said, "an interpreter of the life of the people, particularly of the life of the poor." And she became just that: an interpreter in color.

Alma Thomas

"A world without color would seem dead. Color is life."

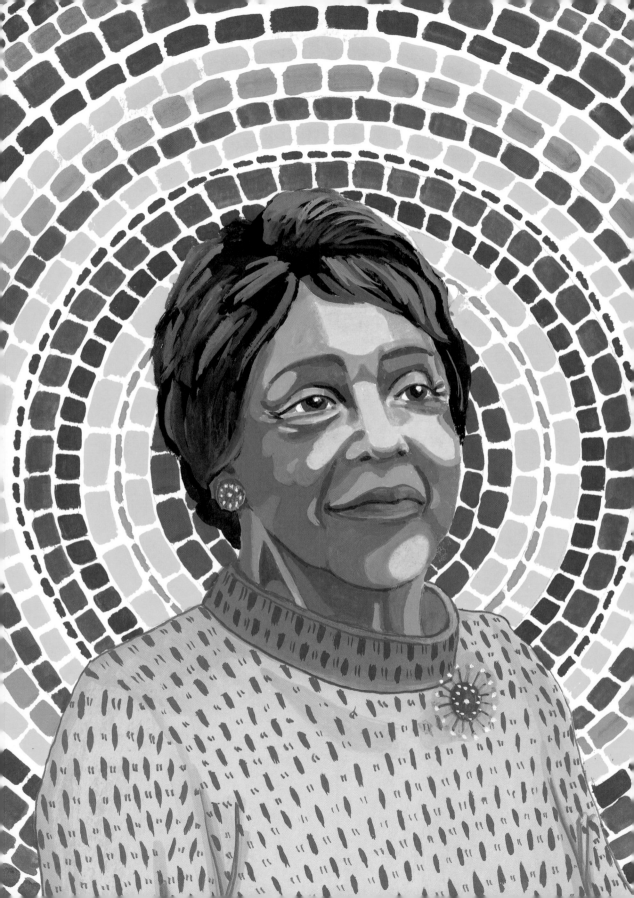

Alma Thomas

Fields of Color

The television set was flickering in the corner. There were so many people squashed in the tiny room that you couldn't lift a glass of iced tea to your lips without nudging someone with your elbow. There were few televisions in the neighborhood, besides, when you are witnessing a great moment in history, you want to share it with the people you love.

It was July 20th, 1969 in America and everyone had been anticipating this moment for a long time, barely believing it was actually going to happen. Was a human really going to set foot on the moon? Alma watched as the countdown began, then Apollo 11 blasted into space. Her eyes were on fire! She was as lit up as that rocket. Most people came away with a deep feeling of excitement that day. But for Alma, this would have a lasting impression. She would recreate this moment again, but in her art and in her own way.

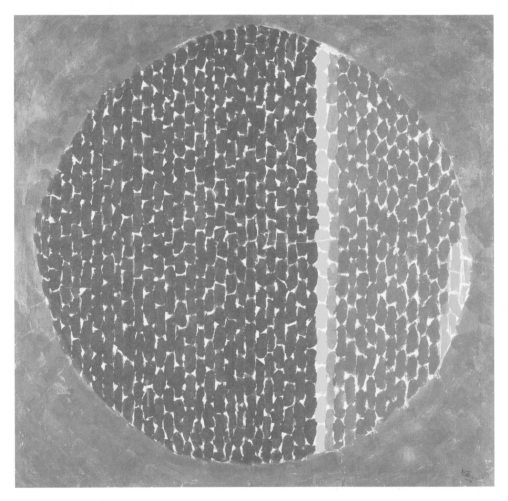

Snoopy Sees Earth Wrapped in Sunset, 1970

Alma was born in the horse and buggy days, as she put it, before the Wright Brothers took their first flight. She had spent her childhood in Columbus, Georgia. There in America's Deep South, segregation was the law of the land. In the 1890s, black people had few rights: they were not allowed to vote; they were not allowed to go to the same schools, restaurants or hospitals as white people. They could not even use the same bathrooms or drink water from the same water fountains. Alma's childhood was filled with rules and fear. She was fifteen when her family moved to Washington, leaving a hard life behind in search of a better future.

Alma had always dreamed of becoming an architect, as she was numeric and skilled in mathematics. Instead, in 1921, after being approached by Professor James Herring at Howard

University, she chose to become one of the first students in its new art department. After she graduated she became an art teacher. The children loved her! She was always so inventive and kind. There wasn't much time to create her own art though. It was only years later when she retired that she could really focus on painting. Encouraged by her artist friend, Loïs Mailou Jones, Alma began experimenting with making modern, abstract art. She was sixty-nine.

For Alma, color was everything. People could see influences from older traditions in her work, such as ancient mosaics and quilt-making and the colorful collages and paintings of Henry Matisse and Wassily Kandinsky. She was linked to a group of artists called the Washington Color School, too. These artists were known for creating art inspired by Color Field painting, where large canvases were filled with flat expanses of color. But Alma's art was distinctive. Her view of things was different. She imagined views of gardens from above, or looked skyward to the stars, then expressed her joy in carefully ordered splashes of color.

Through her art, Alma became an important role model for women, African Americans, and older artists. In 1972, she was the first African American woman to have a solo exhibition at New York's Whitney Museum of American Art. She was invited to the White House by President Jimmy Carter and, years later in 2009, two of her paintings were chosen by Michelle Obama to be hung in the White House.

She would often work at the kitchen table, with her old tins bristling with brushes and the table a jumble of paint tubes and pieces of paper. Carefully, she would lay down short daubs of color with brushstrokes of vibrant red, orange and yellow on white canvas. This one was called *Snoopy Sees Earth Wrapped in Sunset* (1970). Alma recalled that wonderful day the world's eyes were fixed on the heavens, and how she beamed as she glimpsed the infinite possibility of life, progress and humankind.

Suzanne Valadon

"I found myself, I made myself."

Suzanne Valadon

Life as it is

There are some people who take your breath away. There is something about the way they dance through life. The way they make you feel when they look at you. It was not just Suzanne's beauty—and she was very beautiful—it was the way she could connect with anyone, from the homeless to the rich and famous. There was a kind of vulnerability about her, yet she was the most capable person. And fearless, too.

Suzanne grew up on the streets of Montmartre in Paris. She did not know her father. Her mother tried to make ends meet by washing clothes. By the age of ten Suzanne was doing odd jobs to support herself. She did everything from selling vegetables and waitressing to making hats and funeral wreaths. Then she joined a circus. She was only fifteen, but she was magnificent! She walked the tightrope as if it was the most natural thing in the world to do. But then she fell. With her back hurt so badly, her career as an acrobat was over.

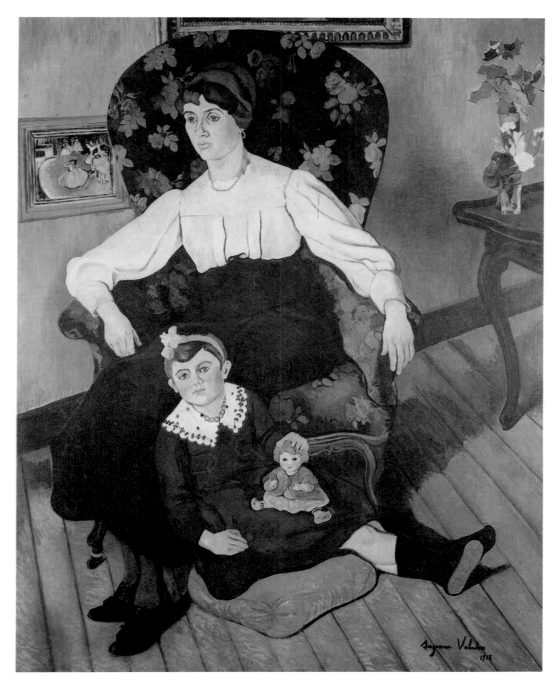

Marie Coca and her Daughter Gilberte, 1913

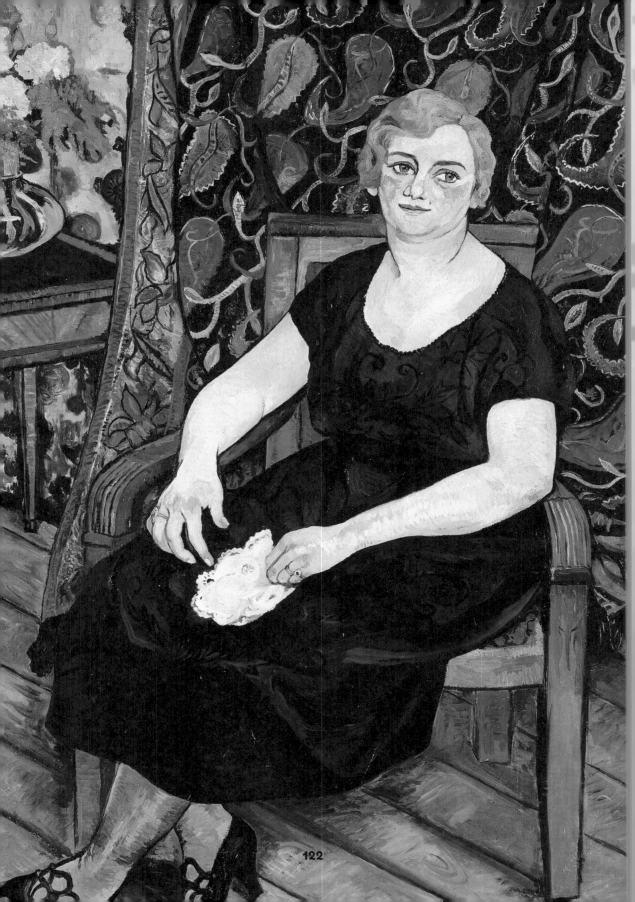

Montmartre in the 1880s was home to many artists. Suzanne seemed to know all of them. They asked if she would model for them, and soon she was modeling full-time. The most famous artists in Paris painted her: Pierre-Auguste Renoir, Berthe Morisot and Henri de Toulouse-Lautrec. When she was not modeling she was causing a sensation somewhere. She loved going to the cabaret, and was known for sliding down the banister at her favorite nightclub wearing nothing but a mask.

OPPOSITE: Madame Levy, 1922

Suzanne was intelligent and curious, and loved art. She watched the great artists at work as she modeled for them. She began to experiment with drawing and painting, using their techniques to mix her own colors. She had no formal training and soon became a fully self-taught artist. When the famous impressionist painter Edgar Degas saw her work he was amazed: "My girl, it's done!" he cried. "You are one of us!" He bought three of her pictures and became her mentor.

Suzanne was as passionate about painting as she was about life, and soon she was a successful artist too. In 1894, Valadon became the first woman painter admitted to the Société Nationale des Beaux-Arts. This recognition was a major French artistic accomplishment!

She mostly painted nudes or portraits, but they were different to those painted by men. They were not posed or grand. They showed women's bodies as a woman sees them, and in normal, everyday scenes. Her subjects were mostly friends from the working class. Her paintings were real and unromantic, with bright colors, big brushstrokes and heavy black outlines instead of the more traditional use of ink and watercolors. A few people said they were unfeminine and unappealing, but they were missing the point. She was painting a side of life that other artists avoided. Her art was as honest and direct as she was.

After the First World War, Suzanne became even more well known. Her work began to be exhibited across the world, and today you will find her pieces in famous art galleries, such as the Centre Pompidou in France and the Metropolitan Museum of Art in New York.

Suzanne's personal life attracted as much attention as her art. She had love affairs with famous painters and composers. She fed caviar to her cats on Sundays, and her bad drawings to her pet goat. She wore corsages made of carrots, just to surprise her friends and make people smile. There was no denying that she was a free spirit and an incredible artist. When she died, she was painting at her easel. Her funeral was attended by all the great artists in Paris and was an event to remember. Suzanne proved that no matter where you came from, no matter how difficult your circumstances were, you could be whatever and whoever you wanted to be.

Hall of Fame

KENOJUAK ASHEVAK
1927–2013
Canada

Kenojuak Ashevak is celebrated for pioneering a modern form of Inuit art. She drew inspiration from her community's connection with nature and her print *The Enchanted Owl* has become the most recognizable work of Canadian Inuit art. Ashevak was involved in setting up a group that enabled Inuit artists to earn a living from their work.

BARBARA HEPWORTH
1903–1975
United Kingdom

Barbara Hepworth is one of Britain's most significant modern artists. Her pioneering sculptures made from wood, stone and bronze were inspired by the human figure and the British landscape. During her lifetime she was commissioned to create a number of public artworks, including for the United Nations in New York. Two museums are dedicated to her work.

HANNAH HÖCH
1889-1978
Germany

German artist Hannah Höch was the only female member of the 1920s Dada movement. Her innovative photomontages made from magazine and newspaper clippings were radically different from the realistic paintings popular at the time. Höch used her art to challenge ideas about a woman's role in society and to criticize the government.

TOVE JANSSON
1914-2001
Finland

Tove Jansson was a painter, illustrator and author, whose Moomin characters made her world-famous. She began her career as a teenager, drawing caricatures for a political magazine in Finland. Her first love was painting but, for many years, work on her Moomin comic strips and children's books dominated her career due to their popularity.

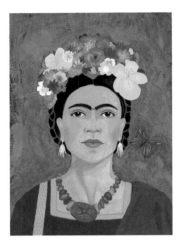

FRIDA KAHLO
1907-1954
Mexico

Mexican painter Frida Kahlo is one of the most important artists of the 20th century. Many of her works depict experiences that are specific to being a woman. Kahlo's self-portraits are celebrated for their honest exploration of her Mexican heritage, her disabled condition and her sexuality.

CORITA KENT
1918–1986
United States of America

Corita Kent was an artist, teacher and advocate for social justice. She became a Catholic nun at the age of eighteen and went on to teach in the order's school, eventually leading the art department. She took inspiration from popular culture and incorporated messages of hope and equality in her vibrant serigraph prints.

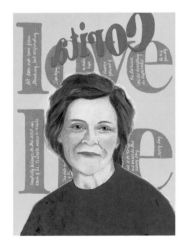

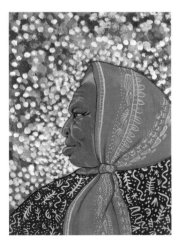

EMILY KAME KNGWARREYE
1910–1996
Australia

Emily Kame Kngwarreye is one of Australia's most significant artists. She and other indigenous women from the Aboriginal community in Utopia were introduced to batik-making in 1977. They used their artworks to prove their right to occupy the land of their ancestors. Kngwarreye was introduced to painting on canvas in 1988 and created more than 3,000 works in the eight years before her death.

YAYOI KUSAMA
b. 1929
Japan

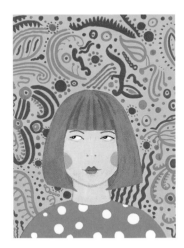

Yayoi Kusama is possibly one of the world's most popular contemporary artists. Born in Japan, she moved to live in New York in the late 1950s, where she established her reputation as a highly creative painter and performance artist. Kusama's work includes paintings, installations, sculpture, film and performance art.

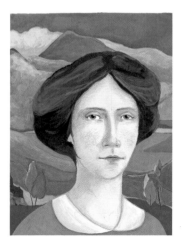

GABRIELE MÜNTER
1877–1962
Germany

Gabriele Münter was a founding member of the group Der Blaue Reiter (The Blue Rider) with Wassily Kandinsky. She was influential in developing the Expressionist style of painting that used color to show feeling rather than realism. Münter's distinctive use of bright colors and graphic outlines was incredibly bold for the time.

GEORGIA O'KEEFFE
1887–1986
United States of America

Georgia O'Keeffe is one of America's most important artists and is known as the "Mother of American Modernism." O'Keeffe was one of the first American artists to make abstract art. Her close-up paintings of flowers and bones, and her landscapes of the New Mexico desert reflected her experience of them instead of showing a realistic picture.

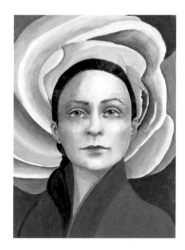

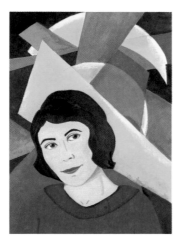

LYUBOV POPOVA
1889–1924
Russia

Lyubov Popova was a key member of the Constructivist art movement in Russia. Her abstract paintings of geometric shapes represented a sense of movement. After the Russian Revolution in 1917, Popova focused on designing everyday objects that could be mass-produced and made available to everyone, including fabrics, clothing, posters and books. She died at the age of thirty-five.

FAITH RINGGOLD
b. 1930
United States of America

Faith Ringgold is an award-winning American artist who works in a variety of different media, including painting, quilt-making, sculpture and performance art. Throughout her career Ringgold has fought for racial and gender equality. She has paved the way for other artists of color and women artists to gain recognition for their work.

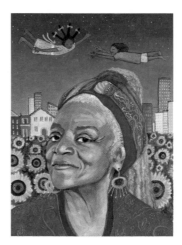

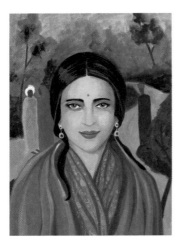

AMRITA SHER-GIL
1913–1941
Hungary, India

Amrita Sher-Gil was born to a Sikh father and Hungarian mother, and lived between India and Europe throughout her short life. Her paintings combined the techniques she learned at art school in Paris with traditional Indian art and brought a modern perspective to rural life in India. She died suddenly, at the age of twenty-eight.

ALMA THOMAS
1891–1978
United States of America

Alma Thomas was an art teacher and artist who developed her signature style of painting after she retired. In her abstract paintings she used thick daubs of paint to create vibrant areas of color. Alma Thomas was the first African American woman to have a solo exhibition at the Whitney Museum in New York in 1972.

SUZANNE VALADON
1865-1938
France

Suzanne Valadon was the first woman painter admitted to the Société Nationale des Beaux-Arts, promoting the best in contemporary French art. She was introduced to painting through her work as a model for artists, including Degas and Toulouse-Lautrec. Valadon's unique paintings showed women in natural, rather than posed, scenes.

Glossary

ABSTRACT art that does not look realistic but instead uses shapes, lines and color to suggest ideas.

AMOUTI a parka jacket worn by Inuit women of Northern Canada, with a pouch sewn into the back for carrying a baby.

APPLIQUÉ ornamental needlework in which pieces of fabric in different shapes and patterns are sewn or stuck onto larger pieces to form a picture or pattern.

AVANT-GARDE a way of describing ideas, people and artworks that are radically new and ahead of their time.

BATIK a method of making patterns on fabric by painting it with melted wax, then dyeing it.

CANVAS a surface for painting on, made from a piece of strong cloth, stretched tightly over a frame.

CARICATURE an image of a person that is exaggerated for comic effect.

CHARCOAL sticks of charred wood that can be used for drawing.

COLLAGE a work of art and a method of making art that involves sticking different materials down onto a surface to create a single image.

CONSTRUCTIVISM an art movement that began after the Russian Revolution in 1917. Artists, architects and designers saw art as a way to create a new and equal society.

CUBISM an art movement that began in Paris in the early 20th century. Cubism involved combining many different viewpoints to create a single painting or sculpture.

DADA a radical art movement that originated in Switzerland. Dada artists were horrified by the violence of the First World War and in response created paintings, collages, poetry and performances that were often humorous or nonsensical.

DREAMING, THE stories and ideas that describe how the natural

world was created by the sacred ancestors of Aboriginal people in Australia.

EASEL a wooden frame for holding an artist's work while it is being painted or drawn.

FRESCO a method of painting directly onto wet plaster on a wall or ceiling, so that the paint combines with the plaster.

FUTURISM an art movement that began in Italy in the early 20th century. Futurists rejected the past and celebrated the excitement of new technology in the modern world.

GOLD LEAF gold that has been beaten into extremely thin sheets so that it can be used by artists to create areas of pure gold in their pictures. Also used in ornate interior decoration, such as theaters.

GREAT DEPRESSION a severe economic downturn that started in 1929 in America and affected the whole world. Many people lost their jobs or were paid so little that they struggled to buy food and pay their bills.

IMPRESSIONISM an art movement that began in France in the late 19th century. The Impressionists wanted to give the impression of a scene, rather than making an exact copy of it.

LANDSCAPE a picture of a landscape or countryside scene.

MINIMALISM a type of abstract art that doesn't try to represent anything. Minimalist art was developed in the U.S. in the 1960s and is often based on geometric shapes.

MODERNISM a series of art movements that impacted the entire world. Modernism turned away from tradition and searched for new ways to express the reality of living in the 20th century.

MURAL a large picture painted directly onto a wall.

PALETTE a board on which paint is mixed. It can also mean the range of colors that an artist uses.

PERSPECTIVE a method of making flat images look three-dimensional by creating the illusion of depth.

PHOENIX a mythological bird that could burn to ashes and rise again with renewed life. It can also mean a person who is regarded as uniquely remarkable in some way.

PHOTOMONTAGE a work of art and a method of cutting, rearranging and overlapping different photographs to create a new image.

POP ART an art movement that was popular in the U.S. and Britain in the 1950s and 60s. Pop artists were inspired by popular culture, including advertising, film and comics.

PORTRAIT a picture or a sculpture of a real person rather than an imaginary one.

PRINT a method of transferring pictures, marks or words onto paper or fabric by using pressure. A stone cut print, for example, starts with a carving on a flat block of stone. The stone is covered with a thin layer of ink, then paper is pressed down on top.

QAMAK a family dwelling used by Inuit families in Northern Canada.

RETABLO a religious picture painted on a small sheet of metal, popular in churches in Mexico.

REVOLUTION a huge change in government and the way a society is organized brought about by sudden force such as in the Russian Revolution or the Mexican Revolution. The word revolution can also mean great changes in other ways, such as in art or technology.

SALON the official art exhibition of the French Royal Academy of Painting and Sculpture in Paris. A salon can also mean a gathering of people where the purpose is to learn or discuss matters of art and culture.

SCULPTOR an artist who makes sculptures.

SCULPTURE a three-dimensional figure or object often made from stone, clay or plaster.

SELF-PORTRAIT a picture of the artist who is painting it.

SKETCH a quick drawing. Sometimes artists make several sketches in preparation for a more finished artwork.

STILL LIFE a picture of objects, such as flowers, fruit or household items.

SURREALISM an art movement that began in Europe in the early 20th century. The word surrealism means "beyond realism." Surrealists often painted their dreams or used their imagination to create unusual images based on reality.

Acknowledgements

Thank you to Anna Ridley and Sophy Thompson at Thames & Hudson for your enthusiasm for this project, and thanks to my editor Harriet Birkinshaw, and designer Belinda Webster for helping to make the stories and pictures sing. Thanks to Henry and Sasha Garfit at the Newlyn School of Art for welcoming me into the fold and making it possible for me to learn from some incredible artists. To Pippa Best and Pippa Lilley – this project has benefited so much from your encouragement. Monday mornings will always be more joyful with you around! Thanks to Martin and Kate, KB and other friends too, who always have my back. My focus group of willing, creative, next-generation artists: I can't wait to see what wonders you will create. Hugs and everlasting thanks go to my mum, Marie, for your love and support, and for reminding me that it was time to reconnect with the artist within. And, of course, my love and thanks go to my husband and champion Huw, and our daughter Nell. You are both amazing. Anything is possible with you two by my side. Finally: Nell, I wrote this book because I see a brilliant imaginative spark in you and wanted to create something that might help inspire you to express your uniqueness. I have drawn strength from the stories of the women here, and hope that you and your friends will too.

Bibliography

KENOJUAK ASHEVAK

Boyd Ryan, Leslie. *Cape Dorset Prints, a Retrospective*. Portland: Pomegranate, 2007.

Leoux, Odette and Jackson, Marion E. *Inuit Women Artists: Voices from Cape Dorset*. Toronto, Douglas & McIntyre, 1996.

BARBARA HEPWORTH

Bowness, Alan. *Barbara Hepworth: Drawings from a Sculptor's Landscape*. London: Adams & Mackay, 1967.

Bowness, Sophie. *Barbara Hepworth: Writings and Conversations*. New York: Harry N. Abrams, 2016.

HANNAH HÖCH

Höch, Hannah. Catalogue foreword to Hannah Höch's first solo exhibition at the Kunstzaal De Bron, The Hague, 1929.

TOVE JANSSON

Jansson, Tove. *Moomin: The Complete Tove Jansson Comic Strip, Vol.1*. Montreal: Drawn & Quarterly, 2006.

Karjalainen, Tuula. *Tove Jansson: Work and Love*. London: Particular Books, 2014.

FRIDA KAHLO

Herrera, Hayden. *Frida: A Biography of Frida Kahlo*. New York: Perrenial, 1983.

CORITA KENT

Ault, Julie. *Come Alive! The Spirited Art of Sister Corita*. London: Four Corners Books, 2006.

Dackerman, Susan and Roberts, Jennifer L. *Corita Kent and the Language of Pop*. Yale: Yale University Press, 2015.

EMILY KAME KNGWARREYE

Neale, Margo. *Origins, Utopia: The Genius of Emily Kame Kngwarreye*. Canberra: National Museum of Australia Press, 2008.

YAYOI KUSAMA

Kusama, Yayoi. *Infinity Net: The Autobiography of Yayoi Kusama*. London: Tate Publishing, 2013.

Turner, Grady T. Yayoi Kusama interview. New York: BOMB Magazine, 1999.

GABRIELE MÜNTER

Heller, Reinhold. *Gabriele Münter: the years of expressionism, 1903-1920*. New York: Prestel, 1997.

Jansen, Isabelle. *Gabriele Münter: Painting to the Point*. London: Prestel, 2017.

GEORGIA O'KEEFFE

O'Keeffe, Georgia. *Georgia O'Keeffe*. New York: The Viking Press, 1976.

O'Keeffe, Georgia. *Some Memories of Drawings*. New York: University of New Mexico Press, 1976.

O'Keeffe, Georgia; Hoffman, Katherine. *An Enduring Spirit: the Art of Georgia O'Keeffe*. New Jersey: Scarecrow Press, 1984.

LYUBOV POPOVA

Hutton, Marcelline. *Remarkable Russian Women in Pictures, Prose and Poetry*. Nebraska: Zea Books, 2014.

FAITH RINGGOLD

Glueck, Grace. *An Artist Who Turns Cloth into Social Commentary*. New York: New York Times, 1984.

Ringgold, Faith; Withers, Josephine. *Faith Ringgold: Art*. Washington D.C.: Feminist Studies, Vol. 6, No.1 Spring, 1980.

AMRITA SHER-GIL

Dalmia, Yashodhara. *Amrita Sher-Gil: A Life*. London: Penguin, 2013.

Mitter, Partha. *The Triumph of Modernism: India's Artists and the Avant-garde 1922-1947*. London: Reaktion Books, 2007.

ALMA THOMAS

Foresta, Merry A. *A Life in Art: Alma Thomas 1897-1978*. Washington D.C.: National Museum of American Art Smithsonian, 1981.

SUZANNE VALADON

Rosinsky, Thérèse D. *Suzanne Valadon*. New York: Universe Publishing, 1994.

Hewitt, Catherine. *Renoir's Dancer: The Secret Life of Suzanne Valadon*. London: Icon Books, 2017.

List of Artworks

Dimensions are given in centimeters, followed by inches

p. 13 KENOJUAK ASHEVAK
Guardian Owl, 1997
Etching and aquatint on Velin arches, 80 x 98 (31½ x 38⅝). Reproduced with the permission of Dorset Fine Arts

pp. 16–17 KENOJUAK ASHEVAK
Six-Part Harmony, 2011
Stonecut and stencil on Kizuki Kozo White, 62 x 99.5 (24½ x 39¼). Reproduced with the permission of Dorset Fine Arts

p. 22 BARBARA HEPWORTH
Biolith, 1948–49
Blue limestone (Ancaster stone), 123.2 (48½). Yale Center for British Art, Gift of Virginia Vogel Mattern in memory of her husband, W. Gray Mattern, Yale College, Yale BA 1946. Barbara Hepworth © Bowness

p. 25 BARBARA HEPWORTH
Night Sky (Porthmeor), 1964
Oil and pencil on gesso-prepared board, 70 x 61 (27⅝ x 24⅛). Private collection. Photo © Christie's Images / Bridgeman Images. Barbara Hepworth © Bowness

p. 29 HANNAH HÖCH
Cut with the Dada Kitchen Knife through the Last Weimar Beer-Belly Cultural Epoch in Germany, 1919. Collage, 114 x 90 (45 x 35½). Nationalgalerie, Staatliche Museen, Berlin, Germany. Nationalgalerie, Staatliche Museen, Berlin, Germany © DACS 2019

p. 36 TOVE JANSSON
Abstract Sea, 1963
Oil on canvas, 73 x 100 (28¾ x 39⅜). Private Collection. © Tove Jansson Estate

p. 39 TOVE JANSSON
Moomin's Desert Island, 1953–59
© Moomin Characters

p. 45 FRIDA KAHLO
Self-Portrait on the Borderline between Mexico and the United States, 1932
Oil on metal, 31 x 35 (12¼ x 13⅞). Private collection. © Banco de México Diego Rivera Frida Kahlo Museums Trust, Mexico, D.F. / DACS 2019

p. 46 FRIDA KAHLO
Self-Portrait with Monkey, 1938
Oil on Masonite, 40.6 x 30.4 (16 x 12). Collection of the Albright-Knox Art Gallery, Buffalo, New York. Bequest of A. Conger Goodyear, 1966. © Banco de México Diego Rivera Frida Kahlo Museums Trust, Mexico, D.F. / DACS 2019

p. 53 CORITA KENT
one way, 1967
Serigraph print, 43.2 x 58.4 (17 x 23). Reprinted with permission of the Corita Art Center, Immaculate Heart Community, Los Angeles.

p. 56 CORITA KENT
E eye love, 1968
From *Circus Alphabet.* Serigraph print, 58.4 x 58.4 (23 x 23). Reprinted with permission of the Corita Art Center, Immaculate Heart Community, Los Angeles.

pp. 62-63 EMILY KAME KNGWARREYE
Anwerlarr angerr (Big yam), 1996 Synthetic polymer paint on canvas, 401 x 245 (157⅞ x 96½). National Gallery of Victoria, Melbourne, Australia. Purchased by the National Gallery Women's Association to mark the directorship of Dr Timothy Potts, 1998. Photo Bridgeman Images © Emily Kame Kngwarreye/Copyright Agency. Licensed by DACS 2019

p. 69 YAYOI KUSAMA
No. F, 1959
Oil on canvas, 105.4 x 132.1 (41½ x 52). New York, Museum of Modern Art (MoMA), Sid R. Bass Fund. Photo The Museum of Modern Art, New York/Scala, Florence. © Yayoi Kusama

p. 73 YAYOI KUSAMA
*All the Eternal Love I Have for the
Pumpkins*, 2016
Installation, mixed media. © Yayoi Kusama

p. 79 GABRIELE MÜNTER
Mai-Abend in Stockholm, 1916
Oil on canvas, 60.6 x 45.4 (23⅞ x 17⅞).
Private collection. Photo © Christie's Images /
Bridgeman Images. © DACS 2019

p. 80 GABRIELE MÜNTER
Der blaue See (The Blue Lake), 1954
Oil on canvas, 50 x 65 (19¾ x 25⅝).
Lentos Kunstmuseum Linz. Photo Lentos
Kunstmuseum Linz © DACS 2019

p. 85 GEORGIA O'KEEFFE
Summer Days, 1936
Oil on canvas, 91.8 x 76.5 (36⅛ x 30⅛). Gift
of Calvin Klein. New York, Whitney Museum
of American Art. Photo © 2019 Digital image
Whitney Museum of American Art / Licensed
by Scala. © Georgia O'Keeffe Museum /
DACS 2019

p. 86 GEORGIA O'KEEFFE
Jimson Weed/White Flower No. 1, 1932
Oil on canvas, 121.9 x 101.6 (48 x 40). Crystal
Bridges Museum of American Art, Bentonville,
Arkansas. © Georgia O'Keeffe Museum /
DACS 2019

p. 93 LYUBOV POPOVA
Space Force Construction, 1920–21
Oil with wood dust on plywood 112.3 x
112.5 (44¼ x 44⅜). State Museum of
Contemporary Art of Thessaloniki

p. 95 LYUBOV POPOVA
Architectonic Painting, 1917
Oil on canvas, 83.8 × 61.6 (33 x 24¼).
LACMA, Los Angeles County Museum
of Art. Purchased with funds provided
by the Estate of Hans G. M. de Schulthess
and the David E. Bright Bequest

p. 97 LYUBOV POPOVA
*Prozodezhda no. 1 (Production clothing
no. 1)*, 1921

Gouache on paper, 34 x 21 (13.3 x 8.2). The
Picture Art Collection / Alamy Stock Photo

p. 101 FAITH RINGGOLD
*Tar Beach (Part I from the Woman
on a Bridge series)*, 1988
Acrylic on canvas, bordered with printed,
painted, quilted, and pieced cloth.
189.5 x 174 (74⅝ x 68½). Solomon R.
Guggenheim Museum, New York.
© Faith Ringgold / ARS, NY and DACS,
London 2019

p. 104 FAITH RINGGOLD
The Sunflower Quilting Bee at Arles, 1996
Color litho, 55.9 x 76.2 (22 x 30). Edition
of 60. © Faith Ringgold / ARS, NY and DACS,
London 2019

p. 109 AMRITA SHER-GIL
Group of Three Girls, 1935
Oil on canvas, 73.5 x 99.5 (29 x 39¼). National
Gallery of Modern Art (NGMA), New Delhi.
Photo The Picture Art Collection / Alamy
Stock Photo

p. 115 ALMA THOMAS
*Snoopy Sees Earth Wrapped in
Sunset*, 1970
Acrylic on canvas, 121.6 x 121.6
(47⅞ x 47⅞). Smithsonian American Art
Museum. Photo Smithsonian American Art
Museum/Art Resource/Scala, Florence

p. 121 SUZANNE VALADON
*Marie Coca et sa Fille Gilberte (Marie
Coca and her Daughter Gilberte)*, 1913
Oil on canvas, 161 x 130 (63½ x 51¼)

p. 122 SUZANNE VALADON
Madame Levy, 1922
Oil on canvas 92 x 73 (36¼ x 28¾). Musée
des Beaux-Arts, Cambrai. Photo © Centre
Pompidou, MNAM-CCI, Dist. RMN–Grand
Palais / image Centre Pompidou,
MNAM-CCI

About the Author

KARI HERBERT is an author and illustrator. She studied at Exeter College of Art and her writing, art and photography has been exhibited and published around the world. She grew up in Greenland, but is now living in Cornwall, where she writes a blog for the respected Newlyn School of Art. She has written several books on exploration, women's history and visual culture; her most recent being the award-winning, international bestseller *Explorers' Sketchbooks*, co-authored with her husband Huw Lewis-Jones. When not traveling in wild and woolly places, Kari can usually be found creating by the sea.

Index

Text and original illustrations © 2019 Kari Herbert
Artwork reproductions see p. 140

Edited by Harriet Birkinshaw
Designed by Belinda Webster
Art history consultancy by Laura Worsley and Cleo Roberts

First published in the United States of America in 2019 by Thames &
Hudson Inc., 500 Fifth Avenue, New York, New York 10110

www.thamesandhudsonusa.com

Library of Congress Control Number 2019931886

ISBN 978-0-500-65196-4

Printed and bound in China by Shanghai Offset
Printing Products Limited